JON VAN ZYLE'S
IDITAROD MEMORIES

40th Anniversary Edition

40 Years of Official Race Art

Stories by Jona Van Zyle

Art by Jon Van Zyle

Epicenter Press ™
Alaska Book Adventures ™
www.epicenterpress.com

Epicenter Press is a regional press publishing nonfiction books about the arts, history, environment, and diverse cultures and lifestyles of Alaska and the Pacific Northwest. For more information, visit www.EpicenterPress.com.

Library of Congress Control Number:
ISBN: 978-1-935347-59-0
The Iditarod Trail Committee holds registered trademarks for the following terms and language: Iditarod, Iditarod Trail Sled Dog Race, Iditarod Trail Alaska, Alaska where men are men and women win the Iditarod, The Last Great Race, 1,049 miles, Anchorage to Nome, and Mushing the Iditarod Trail.
Original paintings, prints, and posters from Jon Van Zyle may be purchased at www.jonvanzyle.com

40th Anniversary Anniversary Edition. The hardbound first edition of this title was published in September, 2000 by Epicenter Press.

Printed in: USA

Table of Contents

Foreword

For four decades and forty annual official Iditarod Trail Sled Dog Race posters, Jon Van Zyle, official artist of the Iditarod, has shared his visions, experiences, and love of the 1000-mile trail between Anchorage and Nome with devotees of the race.

A long-time resident of Eagle River, Alaska, where Van Zyle lives with his wife and fellow artist, Jona, and where they raise Siberian Huskies, one of his favorite subjects to paint is no further away from the kennel just outside the back door.

A member of the Iditarod Hall of Fame, Van Zyle competed in the Iditarod race in 1976 and 1979, when the two Alaska institutions were both younger. Back then, the Iditarod was as much a trek as a race. Jon Van Zyle still finds the winter cold and scenic beauty of Alaska thrilling, especially on the back of a dog sled as he and Jona and his best dogs tour the back country of the Great Land.

Jon Van Zyle's Iditarod posters and limited edition prints of "the last great race on earth" bring Alaska's most famous living artist's work to the masses. Van Zyle also paints many other original acrylic works of scenic mountains, rivers, fishermen, and Alaska's wildlife, bringing his Alaska to collectors worldwide.

~ Lew Freedman

Poster Introduction

The Iditarod is more than a sled dog race: it's a thousand-mile journey, a challenge, an Alaska adventure, and a life-changing event. Jon Van Zyle was so moved by his Iditarod experience that he felt the need to capture and record his race impressions. Some men, like Robert Service, have the gift of words to share their experiences. Jon's gift is his ability to paint his stories and, through his alpenglow pinks and blizzardly blues, he invites us to travel along with him.

Jon completed his first race in 1976, after 26 days, eight hours, 42 minutes, and 42 seconds. By the fall of 1976,

 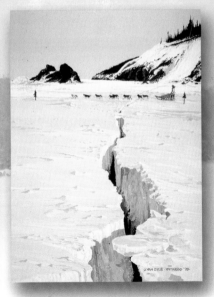

he had translated many of his race memories into twenty acrylic paintings and debuted them in a one-man show at The Gallery in Anchorage; most of the paintings sold immediately. The interest in his Iditarod images prompted Jon to suggest to friends Walt and Gail Phillips, then acting treasurer and secretary of the Iditarod Trail committee, that producing a poster might be a helpful fundraiser for the fledgling race. Dorothy Page, committee chair, and the balance of the Iditarod committee agreed, but they had no money available to help finance the project.

Two of the original paintings from the 1979 Iditarod show at The Gallery.

Going out on a limb, Jon secured a personal loan, financed the first posters, and printed a limited edition of 2,500. In 1977 there were few rules or set protocols for reproduction art; the art print industry was just starting, and no one realized how successful it would become in future years. In fact, Jon decided to remove the date from the first poster because he thought it could be used for many years. At this point he wasn't planning on doing a series of posters, let alone starting a tradition.

The first poster signing was held in March of 1977 and was an immediate success thanks in part to an article in the *Anchorage Daily News*. Fifteen hundred of the first posters carried Jon's printed name but were not personally autographed; they sold for five dollars each. One thousand of the posters were autographed and numbered; they sold for ten dollars. Approximately 100 were also "signed" by one of Jon's favorite leaders, Pikaki. Posters containing her inked paw print are considered a special find by avid collectors and are valued at well over $1,000 on today's secondary market.

Near Shaktoolik, so cold Jon had on every bit of clothing … down to using his long underwear as a scarf.

Belle and Tuffy lead Jon through Rainy Pass in 1979.

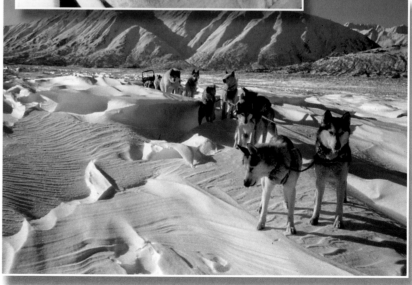

6

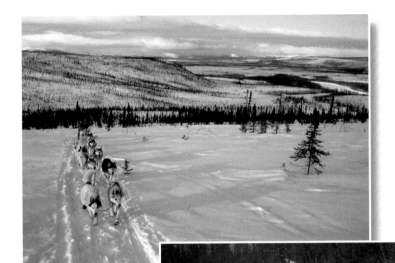

Many steep hills leaving Iditarod on the trail to Shaktoolik.

Sharing a fire along the trail. A chance to rest and dry the wet gear.

In the early years, the race received minimal media coverage. The importance of the first poster was its success as a large-scale marketing item for the Iditarod; it opened the door for future fundraising products and it brought attention to the race. For curious race fans and mushers with a dream, the poster art brought the race trail to life.

In 1978 Jon was asked by the Iditarod Committee to do his second poster, and he agreed to finance another limited edition of 2,500. Like the first year, all 2,500 posters carried his printed name, but only 1,000 were personally autographed and numbered. When Jon discovered an art dealer forging his signature and numbering the posters to sell for the higher price, Jon made the decision that, from there on out, he would personally autograph all his work. What alerted Jon to the forgery was that all the posters had the same number; the dealer had only one of Jon's posters and kept copying that same number!

In 1979 Jon was given the title of Official Iditarod Artist, an honor that he deeply appreciates and still takes very seriously. The original arrangement with the Iditarod Trail Committee was that Jon funded the printing, chose his own poster subject matter, and retained ownership of the original art. The Iditarod retained all profits from posters the committee sold. Today's arrangement with the Iditarod Trail Committee is basically the same.

Jon started the Iditarod print series in 1983. Again, Jon financed the early prints until they were handled by large art publishers. Over the years he has been represented by Millpond Press, Voyager Art, Hadley House, Artique, Ltd., and now, Alaska Limited Editions. Working with national publishing houses had Jon traveling around the country promoting his art. This also gave Jon the opportunity to promote Alaska and the Iditarod to a much larger audience. In 2004, he was inducted into the Iditarod Hall of Fame for his longstanding support and financial commitment to the race.

The popularity of the Iditarod posters and prints is amazing. What started as a one-time, small-scale, good idea of Jon's blossomed into a coveted series for collectors. Not only are the posters and prints collected worldwide, some fans insist on buying the same numbered print each year.

This sled dog race continues to capture the imagination of a high-tech world. Why do people remain so fascinated with an archaic event? Jon and I think the answer is the personal challenge. Our wilderness is vanishing, and today's version of a personal quest is locating a parking place downtown. Computers, cellphones, DVDs, and television allow people access to the entire world from the comfort of their warm, safe homes. However, there is still respect and appreciation—or maybe awe—for the adventurers who dare to dream.

In the 1979 race when Jon asked Dick Forsgren, the checker in Ophir, about the trail into Iditarod, he said "It's 90 miles, 30 miles of trees, 30 miles of a few trees, 30 miles of no trees. Stay between the hills."

Here Jon and several other mushers are in the "30 miles of few trees" trying to find their way on the 90 mile stretch of unmarked trail

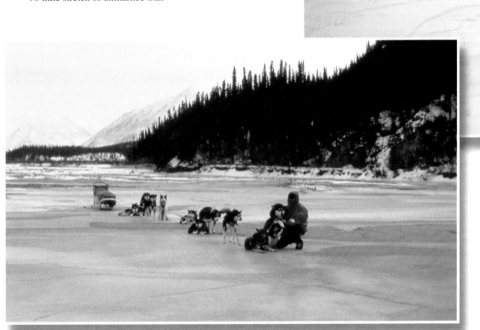

In 1976 Jon's good friend and fellow Iditarod musher, Dennis Corrington traveled together with him. Hell's Gate was a combination of open water, thin ice and overflow on the dangerous south fork of the Kuskokwim River. This portion of the Iditarod trail has been rerouted through the Dalzell Gorge now. This shortened the distance by more than half, and it's certainly less dangerous.

9

A small number of people still take these challenges: people who celebrate the old connections of man to animal and man to nature. It's the spirit of people like Jon, who dare to make this journey, that inspires the race volunteers and fans to support the Last Great Race.

What amazes me most about my husband is his devotion to his art and his endless creative energy. Even after more than forty years of art production, ideas still flow from his heart to his brush. Jon is happiest in the studio, around 3 a.m., listening to Joe Cocker or John Gorka, whistling and dancing along while deeply engrossed in his painting. He may be there in body, but his spirit is somewhere out on the trail.

The infamous "Blow Hole" near Nome staying true to its reputation, during Jon's 1979 race.

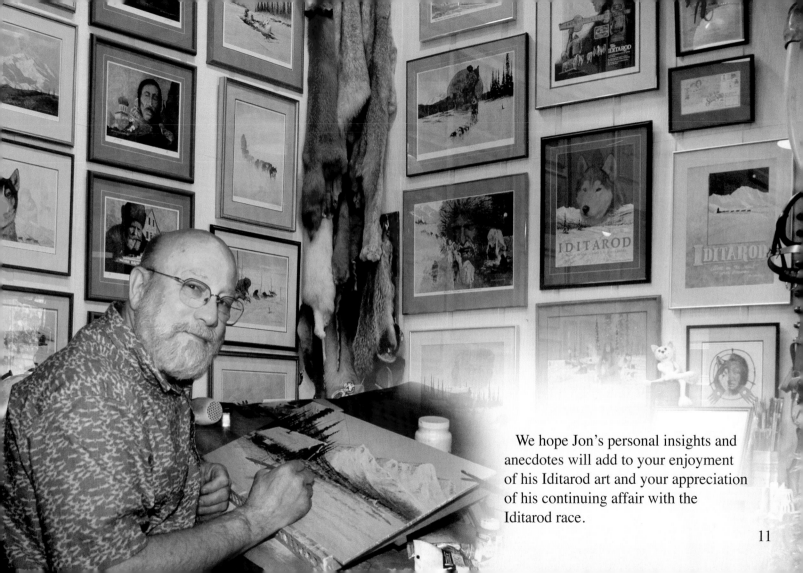

We hope Jon's personal insights and anecdotes will add to your enjoyment of his Iditarod art and your appreciation of his continuing affair with the Iditarod race.

11

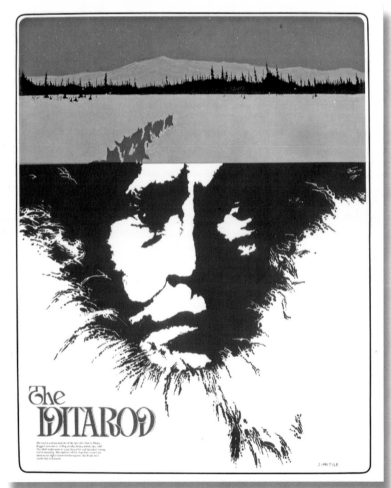

1977

The Iditarod

The trail is a cross-section of the splendor that is Alaska. Rugged mountains, rolling tundra, biting winds, raw cold. The 1049 miles were at once beautiful and dreadful, boring and stimulating. The cadence of the dogs' feet causes my mind to see lights scattered throughout this bleak cold world that is Iditarod.

17 ¼" x 22" 2,500 printed $5 unsigned $10 signed

The original painting for the first Iditarod poster was part of Jon's 1976 one-man show, which featured work based on Jon's experiences in his first Iditarod. Once the decision was made to print a poster for the Iditarod, this was Jon's choice: the creative, graphic style captured the essence of the race for him.

The image conveys the hardships of distance racing. We view the weariness, daily wind, and weather on the musher's face. We see the musher, but the top portion of the image becomes the musher's view of his dog team rhythmically moving forward into the night. The quiet drumming of the dogs' feet in the snow, the soft sounds of the dogs' breath, and the song of the runners sighing over the snow invite tired minds to wander. During his first race, Jon was hallucinating that as each dog's foot touched the snow, it produced a luminescent green light. The light started with his leaders and slowly moved back through the whole team. By the time he reached Galena, the entire team's feet sparked and glowed like live, bare wires brushing together. A memorable night, but only one of the twenty-six memorable nights spent on the trail during his first race.

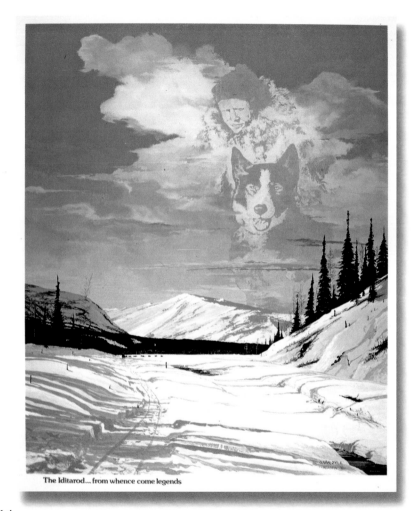

The Iditarod... from whence come legends

1978

The Iditarod ...
from whence come legends

18" x 24" 2,500 printed $10 unsigned $15 signed and numbered

14

Jon chose a montage format for the '78 and '79 posters. By superimposing various experiences in one visual image, he hoped to relate a more detailed story about the trail.

This poster features the spirit of one of Alaska's most famous mushers, Leonhard Seppala. Leonhard and his leader Scotty are overlooking the beautiful trail heading toward Puntilla Lake. Seppala, from Norway, was one of the intrepid mushers who participated in the 1925 serum run from Nenana to Nome. The mushers carried life-saving diphtheria antitoxin serum over the Iditarod Trail, which was the old mail route running across the territory. Seppala and his team of Siberian Huskies traveled 150 miles from Nome to meet the relay. They received the serum packet, turned around, and raced ninety-one miles back across windswept Norton Sound to Golovin where the packet was passed to a fresh team for the next leg of the relay. For his part in the serum run and his winning record in the early All-Alaska Sweepstake Races, Seppala and his huskies earned well-deserved recognition.

The idea for this painting came from the strong feelings Jon had of being part of Alaska's heritage as he traveled the old routes. He experimented with painting styles and glazing techniques and wanted to capture the spirit and energy of the race in a new manner. Jon didn't realize that with his new glazing style—painting as many as forty or fifty thin layers of color—nothing was completely painted out. He was shocked to see that the printing process picked up the underpainting. If you look carefully at the clouds, you'll see the ghost eyes of the earlier positioning of Seppala and Scotty.

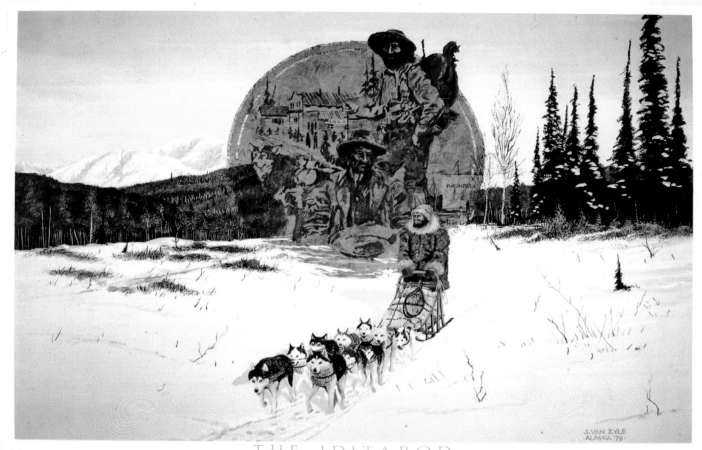

THE IDITAROD

Quietly. Unnoticed. I touched the past. I am.

16

24" x 18" 2,500 printed $15 signed $20 signed and numbered

The Iditarod. Quietly. Unnoticed. I touched the past. I am.

Jon's first Iditarod in 1976 traveled the northern route. In 1977 the trail alternated to the southern route for the first time, and by 1979, Jon felt he had to run it again. He hoped to improve his finish time and see the southern route, but mostly he longed to be out and away on the trail.

In 1975 Jon made the decision to quit his job at Sears and support himself, his wife, and his dogs by painting. He worked hard to build a name and reputation for himself as an artist and, by 1979, was completing over 200 paintings and commissions a year. The rigors of training a dog team for the Iditarod by day and painting by night left Jon exhausted. In support of Jon's race effort, his identical twin brother, Dan, also an artist, flew in from Hawaii to lend a hand. Dan quietly finished the facial details of the musher on this poster late one night while Jon slept undisturbed on his painting table.

Unlike the current well-groomed, well-marked Iditarod trail, early racers spent much of their time breaking trail; mushers averaged about twenty-three days on the trail for the first five years. Spending time on the same routes used by the early goldminers and pioneers invites reflection about their lives. Overwhelmed by the grandeur of nature, and humbled by the determination of those who have preceded you, you come to accept and appreciate all that has brought you to this point, on this trail, this day. Jon used sepia tones to honor the past and a circle-motif around the musher's head to signify completing the circle of the trail's use from past to present. This poster features the Siberian Huskies from Jon's 1976 finishing team. Starting with the leaders, the dogs are: Shanda and Keelik, Pikaki and Bashful, Nome and Bobo, Kitten and Smokey, and Tschiggo and Pele.

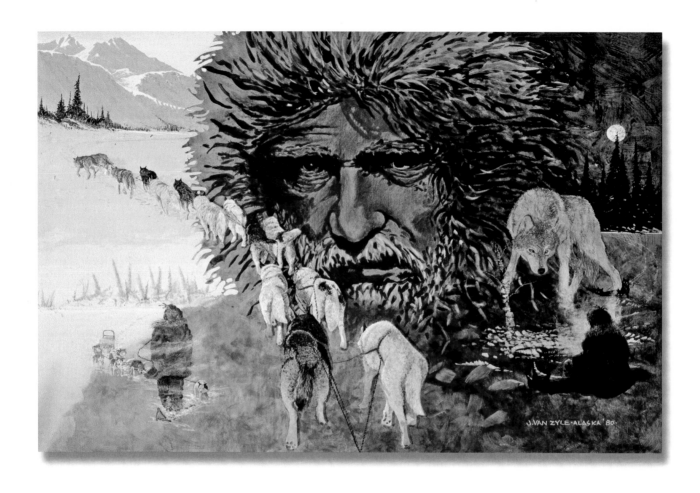

24" x 18" 2,500 printed $18 signed and numbered

1980

The Iditarod ... Alone.
Together. Teamwork Strengthened in Solitude.

This second sepia-toned montage depicts the fatigue of constant travel. Jon's 1979 race was very windy, and the trails constantly disappeared under drifting snow. The hours and miles of laboriously breaking trail on snowshoes between Ophir and Iditarod helped to blur the days into nights. On the plus side, the many sightings of wolves during the race, and a few special close encounters with them, were wonderful distractions from the wind.

The interdependency and close working relationship between musher and dogs grows in adverse conditions. This poster features Jon's 1979 dog team of Siberian Huskies, including, from wheel position forward: Hokulea and Moki, Pikaki and Princess, Kekoa and Seppy, Tschiggo and Strelka, Tuffy and Smokey, Shanda and Bashful, and Kitten and Belle. Many of Jon's dogs were given Hawaiian names which carry warm Hau'oli memories of his island years onto the cold Alaskan trails.

19

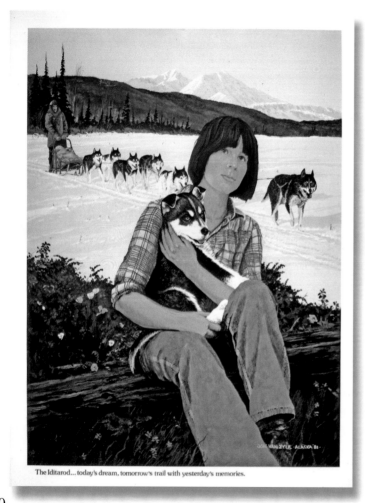

The Iditarod... today's dream, tomorrow's trail with yesterday's memories.

1981

The Iditarod ... today's dream, tomorrow's trail with yesterday's memories.

18"x 24" 2,500 printed $20 signed $25 signed and numbered

1981 marked the Iditarod's eighth year. The media started to take notice of the race, and coverage was reaching the lower 48 states and Europe. The mushers finishing in the top ten were becoming recognized heroes, and youngsters were picturing themselves entering the Last Great Race.

The dream of running Iditarod has led many people, from all walks of life, to head north into a partnership with sled dogs. This year's poster acknowledges the dreams and hopes of a younger generation that will aspire to the trail. Jon's stepdaughter Michelle David, then twelve years old, modeled for the poster along with her puppy Anchor. Although Jon used Michelle as his model, he purposely left the figure's gender ambiguous. Jon hoped that all children could see themselves and their pup leading a team into Nome.

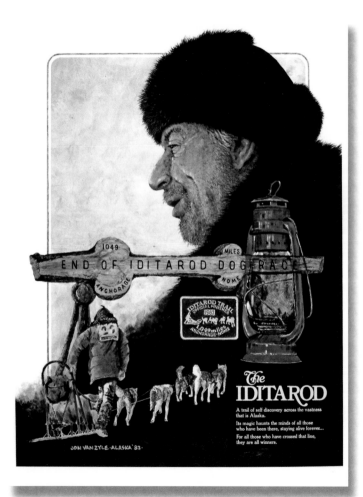

1982

The Iditarod. A trail of self-discovery across the vastness that is Alaska.

Its magic haunts the minds of all those who have been there, staying alive forever ...

For all those who have crossed that line, they are all winners.

18" x 24" 2,500 printed. $20 signed $25 signed and numbered

The 1982 poster format returned to a graphic art style. Featured is Gene Leonard, the 1979 red lantern recipient. The red lantern is presented to the last team crossing the finish line to symbolically light their way home. Gene and his wife, June, were also longtime race volunteers who checked in teams at Finger Lake; their warm food and encouraging words bolstered the spirits of many teams in the early race years.

Jon tried to highlight the race tangibles of crossing under the famous burled arch in Nome, receiving the finisher's belt buckle, and winning the red lantern. In the early years, the cash rewards were small compared to the pride of completing a trip that most people thought impossible. Jon recognized winning as important, but in an odyssey like the Iditarod, getting to the finish line makes you a winner.

By 1982, Jon's skills and reputation as an artist were on the rise. He regularly traveled Outside for one-man shows, and his work gained popularity in the European market; he could no longer keep up with the demand for over 250 original paintings a year. By reproducing popular paintings in a print format, Jon found he was able to meet growing gallery demands for his work. Jon also signed with Millpond Press, one of the largest publishing houses at the time.

23

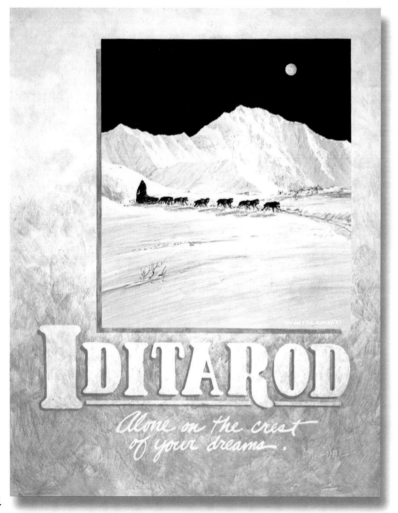

1983

Iditarod. Alone on the crest of your dreams.

16" x 20" size. 3,000 printed $20 signed

By 1983 it was becoming very confusing to the growing number of collectors to have the same poster available either autographed or autographed and numbered. Jon made the decision to stop numbering the posters and start a separate, smaller edition of 500 signed and numbered collectors' prints reproduced on a heavier grade of paper.

This year's poster marks a transition in the focus of the poster art. The first series of six posters were dedicated to the emotions of running the race. The second series introduces a new size, 16" x 20", and features various people, dogs, and aspects of the race. The subject of the 1983 poster is Rainy Pass, the highest point on the trail with some of the most spectacular scenery. Simply running the Iditarod is a high point in a musher's life: to reach the trail is the culmination of so much work and so many dreams, that actually traveling the trail with your four-legged friends becomes a natural high.

Jon's last Iditarod race was in 1979, but Jon trained his team for a 1983 revival run of the All Alaska Sweepstakes which ran from Nome to Candle and back: 408 miles. He shattered his left knee during this race, and the ensuing surgery and long recovery period tempered his desire for distance racing.

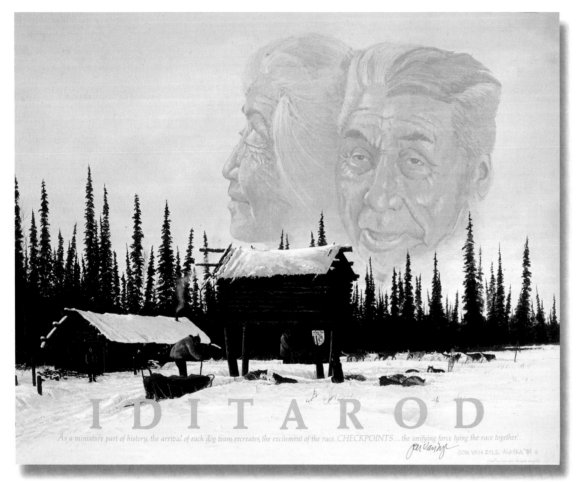

IDITAROD

As a miniature part of history, the arrival of each dog team recreates, the excitement of the race. CHECKPOINTS...the unifying force tying the race together.

JON VAN ZYLE · ALASKA '84 ©

20" x 16" 5,000 printed $20 signed

The Iditarod. As a miniature part of history, the arrival of each dog team recreates the excitement of the race ... Checkpoints ... the unifying force tying the race together.

From 1973 through the 1977 race, the trapping cabin of Miska and Katherine Deaphone was the Salmon River checkpoint and a favorite rest stop for the mushers. Miska's hospitality and Katherine's soups and stews offered a warm meal and a safe haven on the trail. Without the high-tech food cookers and other technological advances of today, the race was a longer, slower trip and people were more willing to share meals and trail news as they traveled. This made for a festive feeling of visiting friends; whether they were old friends or newly introduced didn't seem to matter because the coming together for the Iditarod brought a definite sense of community. After Jon met Miska at the checkpoint, the men became close friends, and Jon spent some time living and painting in Miska's village of Nikolai.

Unfortunately, the Bear Creek wildfire of 1977 destroyed Miska's cabin along with a heartbreaking 361,000 acres of adjoining land; only Miska's storage cache remained after the fire. Now called the Farewell Burn, this 93-mile stretch between checkpoints is the longest, and possibly the roughest, run. In years of minimal snowfall, the charred stumps and rough terrain are merciless on sleds and mushers. For many of the older mushers who still race today, passing this area stirs many emotional memories.

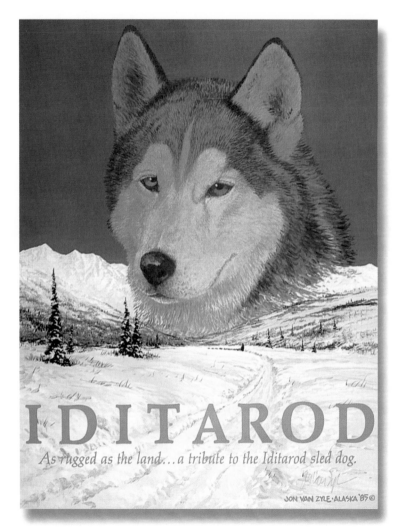

As rugged as the land...a tribute to the Iditarod sled dog.

IDITAROD

JON VAN ZYLE·ALASKA'85©

1985

Iditarod. As rugged as the land ... a tribute to the Iditarod sled dog.

Although some of Jon's art is of a specific mountain or river area, much of it is of typical Alaska terrain. Jon prefers to incorporate characteristics of several possible locations, so the viewer can picture their own special "spot." This seems to work well: at Jon's shows, there can be ten people in a single day, all referring to the same image, who are sure they know the exact place depicted and say, with great excitement, "I've been there many times and I didn't think anyone else knew about it."

16"x 20" 5,000 printed $25 signed
(A limited few were "signed" by Bobo's foot at autograph parties)

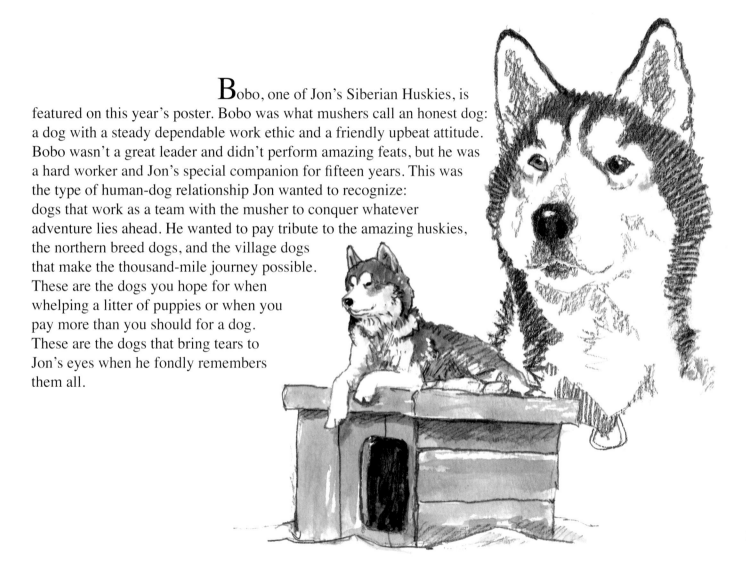

Bobo, one of Jon's Siberian Huskies, is featured on this year's poster. Bobo was what mushers call an honest dog: a dog with a steady dependable work ethic and a friendly upbeat attitude. Bobo wasn't a great leader and didn't perform amazing feats, but he was a hard worker and Jon's special companion for fifteen years. This was the type of human-dog relationship Jon wanted to recognize: dogs that work as a team with the musher to conquer whatever adventure lies ahead. He wanted to pay tribute to the amazing huskies, the northern breed dogs, and the village dogs that make the thousand-mile journey possible. These are the dogs you hope for when whelping a litter of puppies or when you pay more than you should for a dog. These are the dogs that bring tears to Jon's eyes when he fondly remembers them all.

29

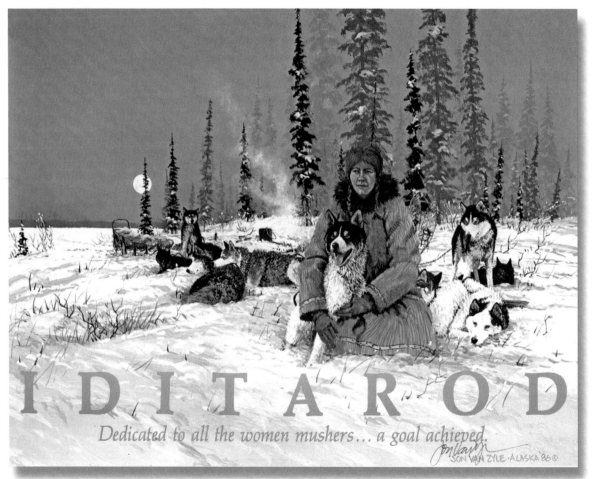

IDITAROD

Dedicated to all the women mushers… a goal achieved.

JON VAN ZYLE · ALASKA '86 ©

30

20" x 16" 5,000 printed $25 signed

1986

Iditarod. Dedicated to all the women mushers … a goal achieved.

In 1985 Libby Riddles won the Iditarod; suddenly, the race was receiving more publicity than it had in the previous twelve years combined. People were amazed that a demure young woman could race—not only race, but race to win.

Women had been running in the Iditarod since 1974: Mary Shields and Lolly Medley were the first women to complete the race that year. By 1985, Susan Butcher had completed seven Iditarods. She finished in nineteenth place her first year and continually moved up with two ninth-place finishes, two fifth-place finishes, and two second-place finishes. Susan has an unmatched string of successes from 1986 through 1993 that no one has equaled today: four firsts, two seconds, one third, and one fourth.

Jon wanted this poster to honor all the women who follow their dreams into the race. It wasn't meant to depict a specific woman but to recognize women's traits of determination, strength, and skill, as well as their gentle nurturing abilities. Jon's stepdaughter Michelle David and his dogs Kekoa, Tschiggo, and Mosby were the models. The poster must have struck a chord with fans because it sold out rapidly. As a musher living in Ohio in those days, struggling to find snow and training trails, this poster fired my determination to head north with my team.

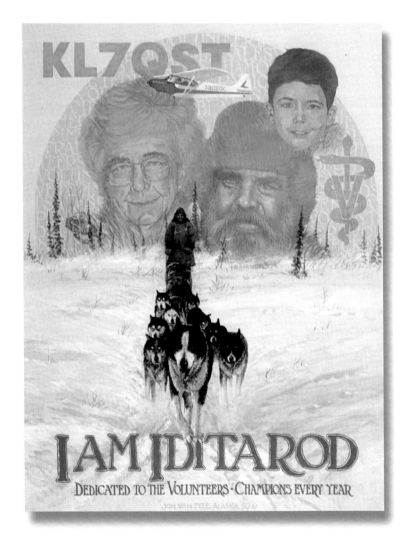

1987

I Am Iditarod
Dedicated to the volunteers
Champions every year

This poster was a bouquet of thank-yous for the many volunteers; without them there wouldn't be a race. Some people dream of running the race, and others with Iditarod fever dream of working at the race and donating their time. Not only Alaskans volunteer: there are fans from the Lower 48, foreign countries, sponsors, and supportive family members of racing mushers who work behind the scenes. The thought and design for this poster placed a supporting circle of people and activities behind the musher.

16" x 20" 5,000 printed. $25 signed.

Jon's mushing companion and friend Darrel Reynolds was the model for the musher, and Darrel's leader Sundance is in front of his team. Vera Gault, Jon's former mother-in-law, is representative of all the telephone hotline operators, dropped dog caretakers, crowd controllers, timers, checkers, cooks, and clean-up crew volunteers. Jon's stepson, Bobby David, was the model for the musher's patient, and hopefully, understanding family who stands behind the musher's efforts. The snowmachine honors the hardy trailbreakers who pack and mark the 1,000-plus miles from Anchorage to Nome. The Supercub airplane credits the Iditarod Air Force that flies hundreds of hours and moves thousands of pounds of freight, dogs, and volunteers over inhospitable land in dangerous winter conditions. A large caduceus, the emblem of the medical profession, acknowledges the growing number of veterinarians and vet technicians who monitor the health and safety of the hundreds of hardworking canine athletes involved in the race. Jon salutes ham radio operators, who handled most of the race communications in the early days of the race, with the call letters KL7 QST. KL7 is an Alaska identification number, and QST means "anyone respond."

33

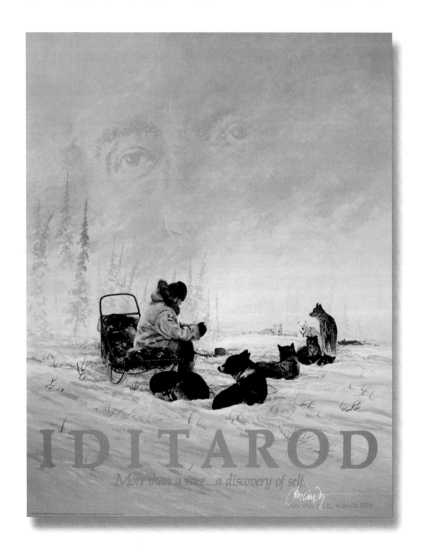

1988

Iditarod. More than
a race ... a discovery of
self.

16" x 20" 5,000 printed $25 signed

The theme featured this year is the inner battle against oneself rather than the outward struggle of musher and team against the trail. Unless you have traveled in sub-zero weather by yourself for long distances, you don't realize the energy and determination it requires. The physical challenge of the 1,049 miles might not be as difficult as the mental and emotional fears, doubts, and fatigue that must be mastered to complete the race. To challenge and survive the race becomes a discovery of self. Jon says that running the Iditarod completely changed his outlook on life: he felt empowered with the realization that he could do anything he put his mind to.

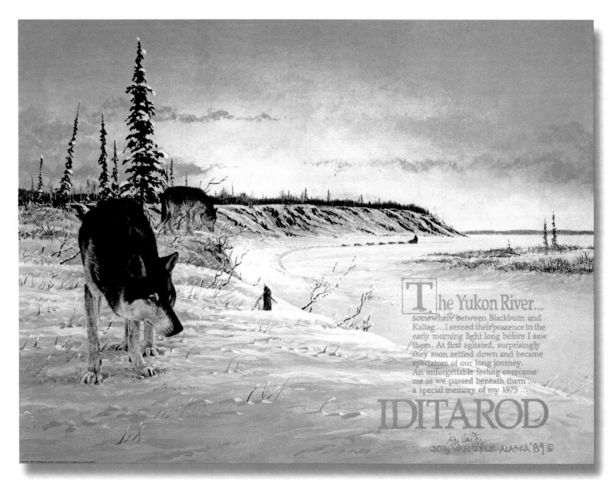

The Yukon River...
somewhere between Blackburn and Kaltag... I sensed their presence in the early morning light long before I saw them. At first agitated, surprisingly they soon settled down and became spectators of our long journey. An unforgettable feeling overcame me as we passed beneath them ... a special memory of my 1979 ...

IDITAROD

JOHN VAN ZYLE · ALASKA '89 ©

24" x 18" 5,000 printed $25 signed

36

1989

The Yukon River ... somewhere between Blackburn and Kaltag ... I sensed their presence in the early morning light long before I saw them. At first agitated, surprisingly they soon settled down and became spectators of our long journey. An unforgettable feeling overcame me as we passed beneath them ... a special memory of my 1979 ... Iditarod.

For the twelfth Iditarod poster, Jon introduced a size change, additional text, and a new series sharing the stories behind some of his most memorable race experiences.

The wolf pack encounter was special for Jon because it was unusual for the cautious canids to openly show themselves. The wolves continued their interest in Jon and his team as they wound their way down the river, which gave Jon the feeling of being accepted into their wilderness. It was as if the wolves knew he wasn't to be feared and recognized Jon and the dogs as fellow travelers moving across the same great land.

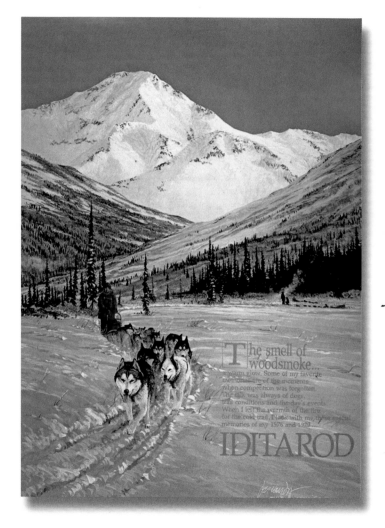

1990

The smell of woodsmoke ... a warm glow. Some of my favorite memories are of moments when competition was forgotten. The talk was always of dogs, trail conditions and the day's events. When I left the warmth of the fire for the cold trail, I took with me these special memories of my 1976 and 1979 ... Iditarod.

18" x 24" 5,000 printed $25 signed

The act of sharing your daily experiences, whether they be terrible, humorous or heart-warming, builds camaraderie. Add a cheerful, crackling campfire and you have an easy atmosphere to initiate a conversation or a friendship. Campfires have long offered a source of physical and emotional warmth to man, and along the race trail, they were especially important in the early years. A ready campfire brought you hours closer to food and rest, and the gathering of teams around a shared fire was a chance to exchange trail information and catch a respite from the crusade. You carried the warmth of the encounter with you back out on the trail.

Discussing the changes that have dramatically shortened current race times, Jon came up with quite a list. Surprisingly, straw was the first item. Nowadays, straw is flown to all checkpoints and provided as bedding for the dog teams; its warmth and comfort allow dogs a more restful sleep. In the early days, a musher cut spruce branches—if the trees were available—but usually the dogs slept curled in the snow. Another factor is a better marked and packed trail. And now there are dog food cookers that eliminate the time-consuming process and problems of fire building, particularly in tundra areas where there's nothing to burn. There is also a better understanding of dogs' and humans' nutritional needs and distance training techniques, and amazing and innovative fabrics now allow mushers to stay warm and dry in lightweight gear. The dogs also benefit with lighter, more comfortable, quick-drying harnesses, booties, and dog coats. All of these improvements make the race faster and safer. There is still fellowship along the trail, but Jon wistfully says it isn't quite the same.

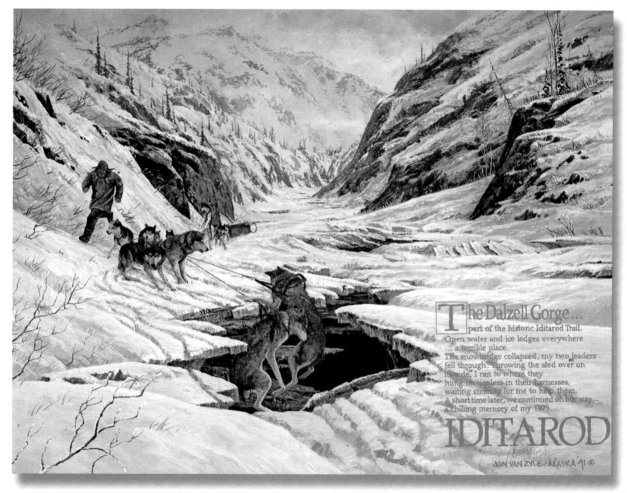

The Dalzell Gorge...
part of the historic Iditarod Trail.
Open water and ice ledges everywhere
... a terrible place.
The snowbridge collapsed, my two leaders
fell through. Throwing the sled over on
its side, I ran to where they
hung motionless in their harnesses,
waiting stoically for me to help them.
A short time later, we continued on our way...
a thrilling memory of my 1979...

IDITAROD

JON VAN ZYLE · ALASKA 91 ©

40

24" x 18" 5,000 printed $30 signed

1991

The Dalzell Gorge ... part of the historic Iditarod trail. Open water and ice ledges everywhere ... a terrible place.

The snowbridge collapsed, and my two leaders fell through. Throwing the sled over on its side, I ran to where they hung motionless in their harnesses waiting stoically for me to help them. A short time later we continued on our way ... a chilling memory of my 1979 ... Iditarod.

As temperatures drop, the rivers become sluggish and then freeze close to their source. This strangles the flow of water, which, in turn, significantly drops the water level. The surface water freezes in descending, shelf-like layers which can be inches or feet apart depending on the swiftness of freeze-up. Suddenly breaking through the surface ice can land you a heartstopping couple of feet above the icy, rushing water.

The calm trust of Jon's leaders permitted him to carry out the necessary rescue. Later, upon quiet reflection, he realized the seriousness of the situation. At the time, however, the steepness of the gorge, the speed of the dogs, and the lack of a trail left little time to think. You run on instinct and hold tight because it's just another experience in the journey of the Iditarod.

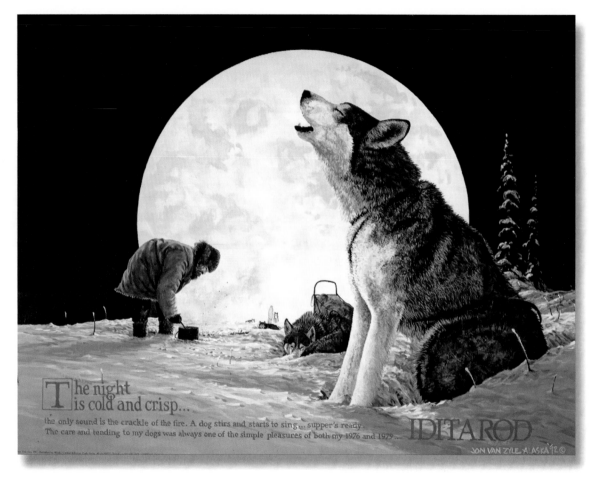

The night is cold and crisp...

the only sound is the crackle of the fire. A dog stirs and starts to sing... supper's ready. The care and tending to my dogs was always one of the simple pleasures of both my 1976 and 1979...

IDITAROD

Jon Van Zyle, Alaska '92 ©

24" x 18" 5,000 printed $30 signed

42

1992

The night is cold and crisp ... The only sound is the crackle of the fire. A dog stirs and starts to sing ... supper is ready.

The care and tending to my dogs was always one of the simple pleasures of both my 1976 and 1979 ... Iditarod

The familiar daily routines associated with the care of animals aren't chores for us; we look forward to spending time with our dogs. Once outside there is always the special reward of a vivid sunrise or sunset, eagles soaring overhead, or the antics of the dogs. For Jon it's especially nice to have a reason to get out of the house and away from the telephone or painting. It becomes a chance to stretch, move around, and do something physical for a change. I think the daily routine of dog care becomes a mantra for most mushers: a ritual that brings peace and enlightenment. Whether you're in the midst of your racing agenda or just your regular daily schedule, it becomes a mental health moment we all enjoy.

This poster failed to catch the luminous beauty of the original painting; it reproduced much darker and didn't quite capture the moonlight glow. No matter how careful the printer is, the limitations of the printing process can't match the depth of color and incandescence of Jon's original paintings. The other side of the coin is that while most people can't afford to pay $10,000 to $18,000 for a Van Zyle Iditarod original, $30 is reasonable for an image that offers a visual journey down the Iditarod trail.

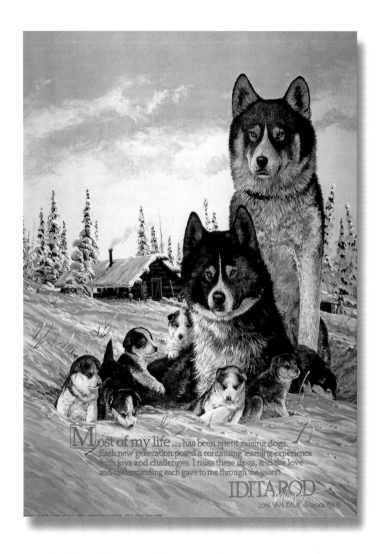

1993

Most of my life ... has been spent raising dogs. Each new generation posed a continuing learning experience with joys and challenges. I miss these dogs and the love and understanding each gave to me through the years ... Iditarod

18" x 24" 5,000 printed $30 signed

A bad back, bad knees, carpal tunnel problems, and growing art and book commitments slowly moved Jon away from keeping a working sled-dog kennel. He had lost his Iditarod team and was losing their offspring; since he wasn't racing, he wasn't breeding new dog replacements. Jon really missed this aspect of dog involvement, so he painted a litter. This poster proved so popular that the Iditarod used it on many of their collector items including jackets, T-shirts, pins, belt buckles, and coffee mugs.

In case you are wondering if Jon still has any huskies, the answer is "yes." When some couples remarry, they get a ready-made family; when Jon and I married and joined kennels, Jon got a well-trained, well-traveled Siberian Husky team. There is a favorite old joke about a musher's Help Wanted ad: "Looking for a female dog handler and kennel manager, experience necessary. Should be strong and caring, love dogs, be a hard worker and have her own truck. Send resume and picture of truck." I had a fast, young dog team and a new dog truck. How could Jon resist?

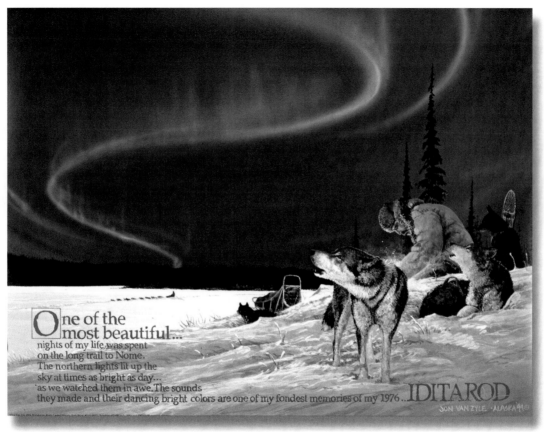

One of the
most beautiful...
nights of my life was spent
on the long trail to Nome.
The northern lights lit up the
sky at times as bright as day...
as we watched them in awe. The sounds
they made and their dancing bright colors are one of my fondest memories of my 1976... IDITAROD

SON VAN ZYLE ·ALASKA 91©

24" x 18" 5,000 printed $30 signed

1994

One of the most beautiful ... nights of my life was spent on the long trail to Nome. The northern lights lit up the sky at times as bright as day ... as we watched them in awe. The sounds they made and their dancing bright colors are one of my fondest memories of my 1976 ... Iditarod.

Jon and his team left the White Mountain checkpoint at about sunset and headed for Nome. Daylight dimmed into darkness and the show began: it was the most incredible all-night lightshow performance Jon had ever seen. While sloshing through Fish Creek, a crescendo of brilliant light accompanied by a swooshing sound stopped the team in their tracks. The shimmering light was bright enough to cast shadows on the snow and held Jon and the dogs transfixed.

Jon swore on a stack of Bibles that he would not paint the Northern Lights because he couldn't capture the ephemeral qualities with paint and brush—all that changed in 1993 when he received an airbrush for Christmas. After much experimentation, he premiered his newfound skills in the 1994 poster. Although the subtleties of Jon's current airbrush skills in rendering Northern Lights far outshines earlier efforts, it was a start ... and a very popular poster. Auroras are one of the rewards when enduring Alaska's long dark winters; we are awestruck by the mesmerizing, magical movement of the lighted streamers. Auroras can pulsate and dance merrily across the sky, flutter and billow like sheets on a clothesline, or radiate like a religious experience. One of the largest aurora study centers is the Geophysical Institute of the University of Alaska, Fairbanks.

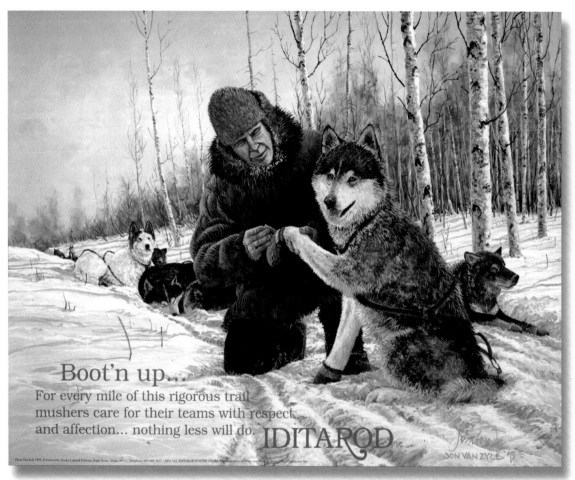

Boot'n up...
For every mile of this rigorous trail
mushers care for their teams with respect
and affection... nothing less will do. IDITAROD

Jon Van Zyle '95

20" x 16" 5,000 printed $30 signed

48

1995

Boot'n up ... For every mile of this rigorous trail mushers care for their teams with respect and affection ... nothing less will do. Iditarod.

With mushers using over 1,000 dog booties per race these days, boot'n up is a major part of the daily trail routine. The booties are used to protect the dogs' feet from sharp crusty ice or other adverse trail conditions; they also allow a sore foot to be medicated and protected so the wound can heal on the go. In the early days, booties were made of leather or denim. Current high-tech fabrics like polar fleece and cordura cloth have added comfort and durability, and the addition of elasticized Velcro closures has greatly expedited the process of boot'n up a sixteen-dog Iditarod team.

Jon's friend Stan Smith and his leader Nikki were the models for this poster, which starts a new series of six focusing on integral parts of the race. Jon helped Stan get started in mushing and supported his two Iditarod races. Although Stan no longer maintains a racing kennel, he is considered a real "dog man" having almost mystical abilities in canine communications. Stan advises and assists many well-known mushers as well as Iditarod hopefuls like his son and daughter who have successfully completed several Jr. Iditarod races.

Jon and I feel it is important to be supportive of novice mushers and the mushing community. Jon has sponsored numerous Iditarod mushers over the years, and we spend time volunteering at races and supporting events with our art. The sport has given us so much over the years that we are happy to be able to give something back.

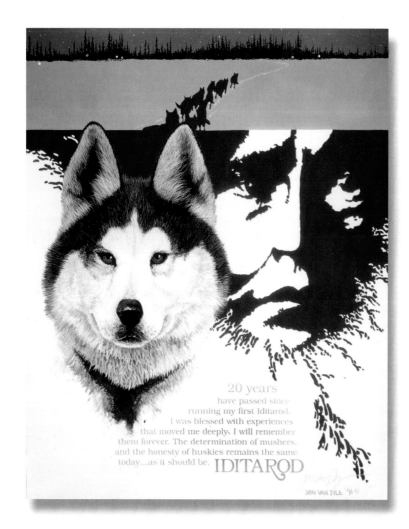

20 years
have passed since
running my first Iditarod.
I was blessed with experiences
that moved me deeply. I will remember
them forever. The determination of mushers,
and the honesty of huskies remains the same
today...as it should be. IDITAROD

JON VAN ZYLE '96

1996

20 years have passed since running my first Iditarod. I was blessed with experiences that moved me deeply. I will remember them forever. The determination of mushers, and the honesty of huskies remains the same today … as it should be. Iditarod.

16" x 20" 5,000 printed $30 signed

Jon found it hard to believe twenty years had passed since his first Iditarod. Looking over the past nineteen years of poster images, he felt the strongest emotional ties to the first poster and decided to use it again—with the addition of a dog—for the 1996 poster.

1996 also marked the twentieth anniversary of Jon's friendship with Dennis Corrington, whom he met on the race trail. 1976 was Dennis's first and only Iditarod, and the men found themselves traveling at about the same pace. Over the many miles, long days, crazy experiences, and practical jokes, they forged a strong bond. They finished the race nine seconds apart, with Dennis receiving the prized Red Lantern Award. The strength of their friendship has been their shared race experiences and their deep love for Alaska, its history and native peoples.

The strength of this poster is the simplicity of the man and dog combination. It is easy to get overwhelmed with the mountain of thoughts, emotions, and images of the race. The basics, however, remain man and dog against nature.

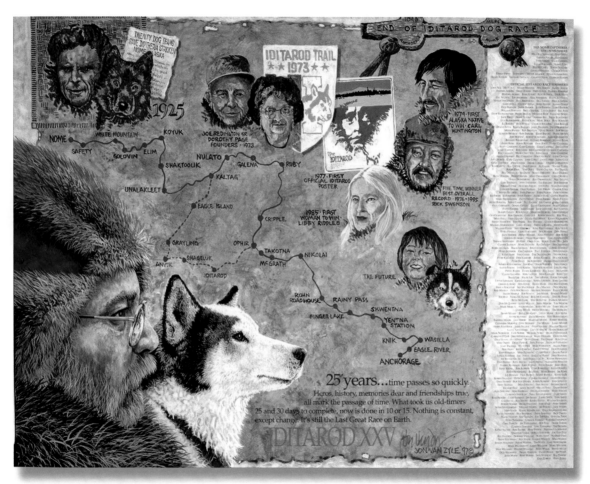

52

20" x 16" 2,500 printed $30 signed

1997

Twenty-five years ... time passes so quickly. Heroes, history, memories dear and friendships true, all mark the passage of time. What took us old timers 25 and 30 days to complete, now is done in 10 or 15 days. Nothing is constant except change. It's still the Last Great Race on Earth. Iditarod XXV.

In 1972 the Alaska Legislature designated dog mushing as the official state sport. In 1973 thirty-four dog teams took off from Anchorage and headed toward Nome in the first Iditarod Trail Sled Dog Race. To mark the twenty-fifth anniversary of the Last Great Race, Jon decided to use a timeline along the trail to highlight some of the important people and occasions in race history.

The timeline starts with racing legend Leonhard Seppala and his leader Togo, who helped relay the life-saving antitoxin serum to Nome during the 1925 diphtheria epidemic. 1973 features Joe Redington Sr. and Dorothy Page, who are considered the father and mother of the Iditarod race for their efforts in creating and organizing the event. If space had permitted, Jon would have included Tom Johnson and Gleo Huyck, who were instrumental in the first years, and Howard Farley and Leo Rasmussen, who organized the Nome end of the race from trail to trophies. The timeline continues with 1974: Carl Huntington was the first native musher to win both the Iditarod and the 1973 Fur Rendezvous Open World Championship Sled Dog Race. It's an accomplishment no one else has equaled since.

The year 1977 commemorates Jon's first Iditarod poster becoming part of the race and Iditarod's first race merchandise. In 1985 women make their presence known as Libby Riddles becomes the first woman to win the Iditarod. Rick Swenson definitely has a spot for holding the best overall race record of five Iditarod wins from 1976 to 1995, an as-yet-unmatched feat. Robin Phillips, daughter of Walt and Gail Phillips, longtime Iditarod race supporters, was the model for the future musher.

Jon includes Nome's famous burled arch, which was carved by race finisher Red Fox Olson. When Olson finished the thousand-mile race in 1974, the end was marked by a line of Kool-Aid sprinkled in the snow and two paper plates on sticks. Feeling the racers deserved more, he created the impressive arch for the 1975 race. The arch collapsed after the last mushers finished the 1999 race: the end of an era.

Woodworker Bob Kuiper came to the rescue and created a new arch for the 2000 race. By combining fifty wood burls, he produced an impressive and welcoming sight for weary mushers.
Lastly, the names of the twenty mushers from the 1925 serum run, and the names of every musher who has completed the Iditarod up to 1996, make up the right margin of the poster.

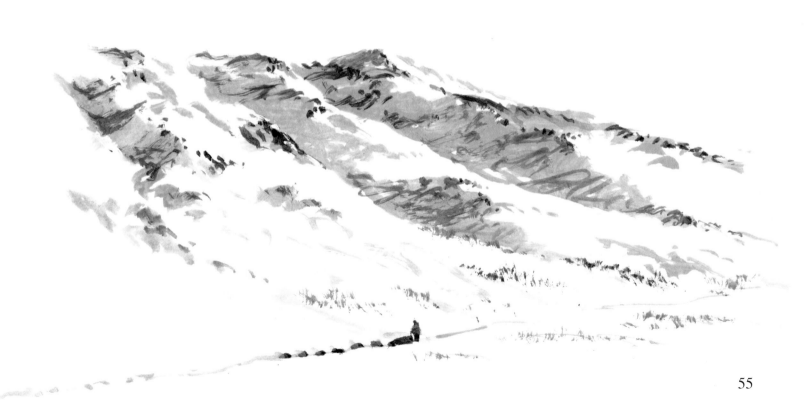

55

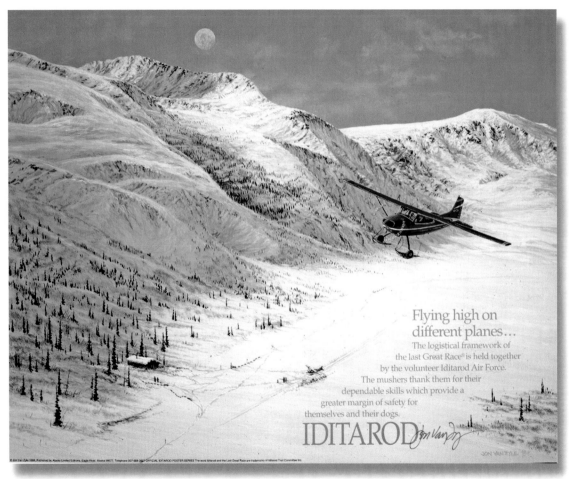

Flying high on
different planes...
The logistical framework of
the last Great Race® is held together
by the volunteer Iditarod Air Force.
The mushers thank them for their
dependable skills which provide a
greater margin of safety for
themselves and their dogs.

IDITAROD

20" x 16" 2,500 printed $30 signed

Flying high on different planes ... The logistical framework of the Last Great Race is held together by the volunteer Iditarod Air Force. The mushers thank them for their dependable skills which provide a greater margin of safety for themselves and their dogs. Iditarod.

This poster draws attention to the volunteers of the Iditarod Air Force and the different perspectives of the trail: from the air and on the ground. The area featured is reminiscent of the terrain near Rohn Roadhouse, Finger Lake, or the Skwentna areas.

The pilots have the advantage of height and a great overview of large expanses of wilderness. As they rapidly cover ground, they spot the problem moose, open leads, and oncoming storms that will surprise the unsuspecting mushers on the ground. The mushers feel that it isn't a destination they want to reach but the "high" of the entire experience. Enlightenment comes with quietly gliding through the vast white winterscape, encountering wildlife and danger, and sampling Alaska with all their senses.

To represent the Iditarod Air Force, Jon featured a Cessna 185 aircraft known as a northern workhorse. An average of twenty-eight small airplanes fly more than 1,200 hours and use an estimated 20,000 gallons of aviation fuel to move freight, people, and dropped dogs along the race trail. Some pilots become so entranced by the Iditarod trail that they also run the race. Don Bowers, Bert Hanson, and Bruce and Diana Moroney—to name a few—have experienced both planes.

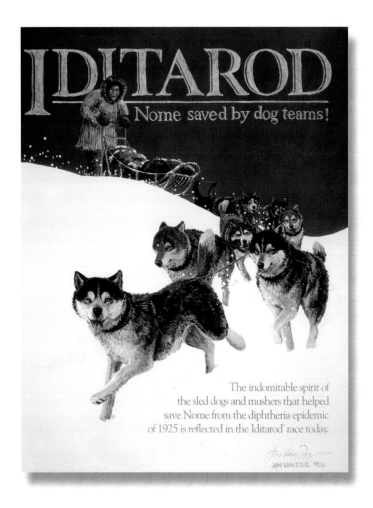

The indomitable spirit of the sled dogs and mushers that helped save Nome from the diphtheria epidemic of 1925 is reflected in the Iditarod® race today.

JON VAN ZYLE '99 ©

1999

Iditarod. Nome saved by dog teams! The indomitable spirit of the sled dogs and mushers that helped save Nome from the diphtheria epidemic of 1925 is reflected in the Iditarod race today.

From 1973 to 1979, a two-minute period of silence was observed before the start of each Iditarod race to honor the memory of legendary musher Leonhard Seppala and the 1925 serum run. The best known dog heroes of the serum run are Balto and Togo, and both of them left Alaska after the serum run.

16" x 20" 1,500 printed $30 signed

In 1927, caring Clevelanders rescued Balto and the team that ran the last leg of the serum run. The team was initially sold to movie producer Sol Lesser, who made a short movie and then sold the team to a "dime-a-look" museum in Los Angeles where they were mistreated. The city of Cleveland purchased the team from the museum and transported them to Ohio to live out their lives with dignity at the Cleveland Zoo. After Balto's death in 1933, his remains were preserved, and he is still a part of the permanent collection of the Cleveland Museum of Natural History.

Togo and the team that ran the longest leg of the relay toured the lower 48 states with Seppala in 1927. In Poland Spring, Maine, Seppala gave fourteen-year-old Togo to wealthy musher Elizabeth M. Ricker. Upon his death in 1929, Togo's body was preserved and given to the Peabody Museum at Yale. In 1964, the Shelbourne Museum in Vermont acquired Togo's mount, and schoolchildren eventually petted away much of his hair.

Mushers rediscovered Togo in 1983 and shipped him back to Alaska. Refitted with new ears and tail, Togo now resides at the Iditarod Trail Headquarters Museum in Wasilla. At the end of 1998, I was organizing an exhibit and programs for the Anchorage Museum of History and Art; the exhibit featured Balto and Togo together again after 73 years. Before moving to Alaska, I had been the assistant curator of the Balto exhibit at the Cleveland Museum and was pleased to have the opportunity to work on the exhibit in Anchorage.

Jon was surrounded by serum run information. Coupled with the January 1999 passing of Edger Nollner, the last surviving serum run musher, Jon decided to dedicate this poster to the spirit and history of the race and chose a graphic art style reminiscent of the 1920s and '30s. The poster doesn't depict a specific musher or dogs: they were all heroes.

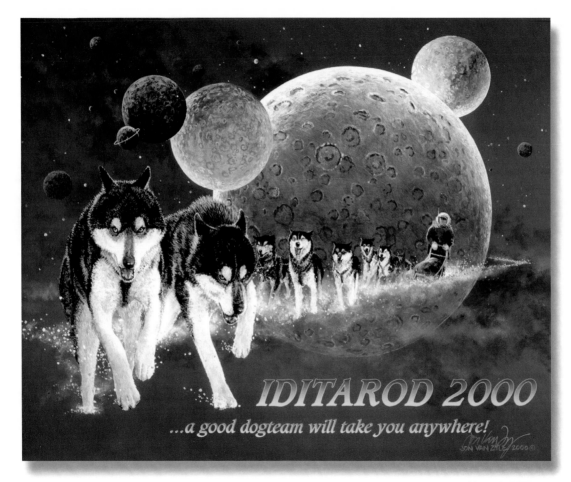

IDITAROD 2000

...a good dogteam will take you anywhere!

JON VAN ZYLE 2000 ©

20" x 16" 1,000 printed $30 signed

Iditarod 2000

... a good dog team will take you anywhere!

With the approach of the year 2000, Jon spent weeks thinking about ideas. He wanted the poster to be special and "millenniumish" without straying too far from the musher-dog relationship of Iditarod.

While brainstorming late one night, I made the comment that a good dog team will take you anywhere you want to go; that concept hasn't changed from the earliest days of mushing to the present time, and I assume it will remain the same into the future. Jon's eyes twinkled and he said, "That's it!" as he reached for the ever-present scrap of paper and pencil. He quickly sketched as he talked: He could see a dog team mushing into the future … a cosmic dog team streaking through space, blazing a trail into unknown territory … it would definitely be something different.

After weeks of celestial research and painting, we viewed the finished artwork. I thought one element was missing: I goaded Jon into giving the musher a space helmet as mandatory trail equipment for the millennium. Little did I realize, but as of 2015, several mushers have started wearing helmets for protection against concussions from falls on the icy trail.

This design was used for a 2000 Iditarod T-shirt, and the bright, glowing colors proved popular. Nevertheless, Jon wasn't sure how his devoted poster collectors would respond to the drastic change in color scheme. After careful consideration, he decided to print a smaller edition … it sold out in less than six months.

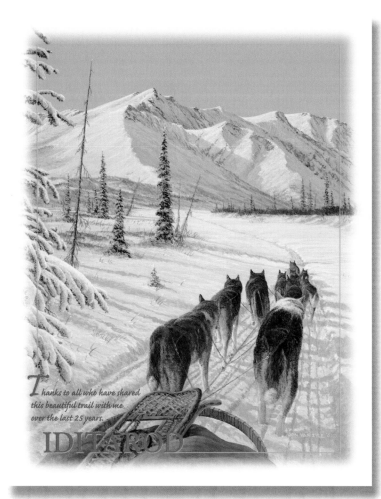

2001

Thanks to all who have shared this beautiful trail with me over the last 25 years. Iditarod.

For his twenty-fifth anniversary poster, Jon has chosen a perfect sunny March day and given you, the viewer, an honest dog team moving steadily through Alaska's wilderness on a trail you can travel forever.

16" x 20" 1,500 edition size $30 signed

In 1976, as Jon approached the solid burled arch signaling the finish in Nome, he didn't want the adventure to be over. He wished he could continue the trip on to Teller, then Wales, then who knows where. Wrapped in a cocoon of memories, after a misty silence, Jon quietly repeated the thought that he never wanted it to end. He is thankful for the continued popularity of the posters and, most importantly, for his fans allowing him to continue this journey.

In 1991, Jon actually did continue the trip on to Teller, then Wales, then Siberia! Jon was a driving force in a group organizing the first Hope Race. The race started in Nome in late March after the completion of the Iditarod race. As one of the race organizers, Jon shepherded thirteen mushers and sled dog teams to Anadyr, Siberia. In Wales, mushers drove their sleds and teams into old Aeroflot helicopters for a short flight across the Bering Strait, then continued the 1,200 mile adventure race, lasting about a month.

It was an emotional, bonding journey for all the participants. I have to say, if Jon wasn't bald already, he would have pulled out all of his hair by the finish.

... Everything but the Kitchen Sink

With piles of food, clothing and winter camping gear stacked around the studio, the logistics of planning a trip by dog team were obvious—as was the idea for this poster.

The title refers to the common mistake of first-time racers who inadvertently overload their sleds. Jon has pictured most of the required race gear carried in an Iditarod musher's sled, or packed in the "drop bags" sent out to the checkpoints along the trail.

This poster is a favorite with many of the school teachers who follow the Iditarod race. Their younger students enjoy searching the picture for the required gear.

Iditarod now offers a very substantial educational program that incorporates the race with learning. The Teacher on the Trail (TOTT) program annually offers one lucky teacher the opportunity to travel the race trail and share their daily experiences and lesson plans online with teachers and students from around the country.

24" x 13" 1,500 printed $35 - Price increase after 11 years.

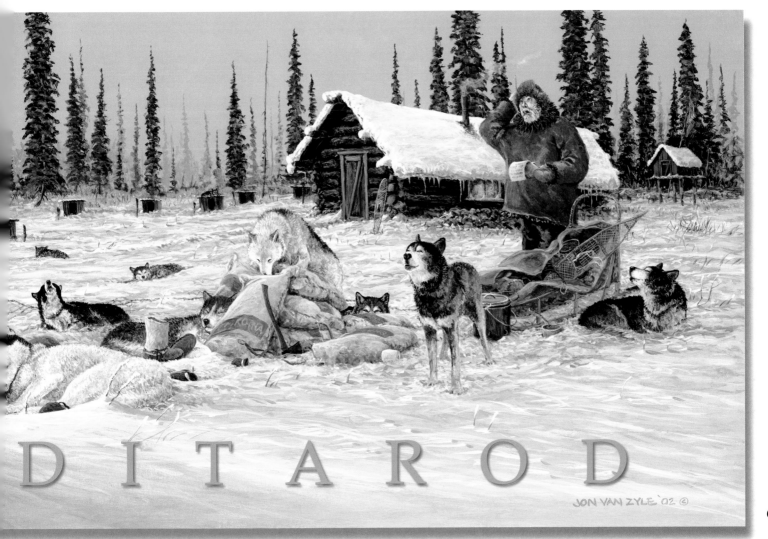

DITAROD

JON VAN ZYLE '02 ©

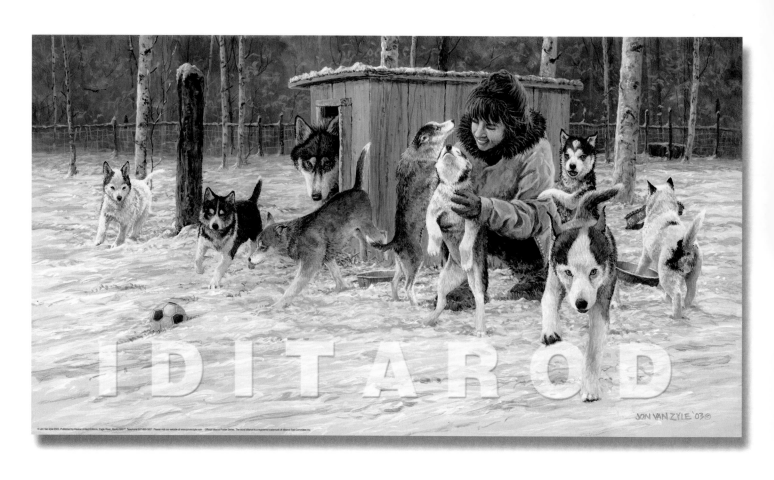

24" x 13" 1,500 printed $35

66

...Puppy Love

Puppies are a rewarding and necessary part of maintaining a dog kennel. To continue in the sport, young dogs need to be introduced into the mix. Each new litter represents the musher's hopes and dreams for the future.

Mushers also dream about finding a trusted helper. It's a huge amount of work and money to raise, train, and race a dog team. Most successful Iditarod mushers also have a team of indispensable handlers. Whether assisting with training dog teams, preparing drop bags, driving to races, or boosting the musher's morale, handlers do it all.

This poster is a "tip of the hat" to all those who work behind the scenes of a successful team. Many of these kennel apprentices have become knowledgeable, competitive mushers in their own right.

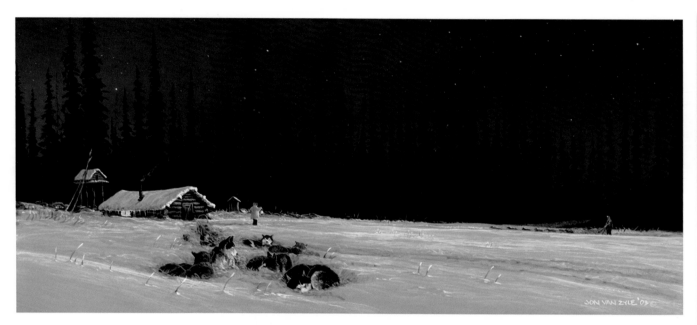

2004 IDITAROD

12" x 24" 1,000 printed $36

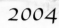

2004

Lighting the Way

After a sub-zero, bone-chilling run, or a particularly harrowing stretch of trail, the lights of a checkpoint are a welcoming beacon. The lights signal warmth, food, comfort, and assistance, if needed.

"Lighting the Way" was an instant success and sold out quickly. It's always exciting to hit a home run! This was also the year Jon was inducted into the Iditarod Hall of Fame, an honor he cherishes.

Another honor was having my art chosen to grace the Iditarod Trail Mail. These are the promotional envelopes carried by each musher over the race trail from Anchorage to Nome, then sold to help support the race.

In 2004, we also flew the race trail with the Claus family, following their daughter Ellie's first race.

The opportunity to visit each checkpoint, see old friends, meet new ones, and camp in the cold was quite an epic adventure in itself.

As if that wasn't enough, Jon and I were chosen as the first husband and wife team of Artists-in-Residence at Denali National Park and Preserve. It truly was a banner year for all of us.

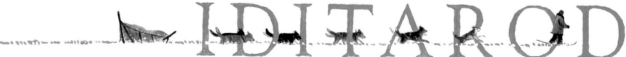

IDITAROD

13" x 24" 1,000 printed $36

2005

Breaking Trail

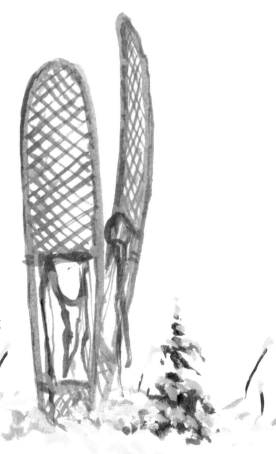

"Breaking Trail" was another popular poster that sold out quickly. The theme harkens back to the earlier days of the race where breaking trail was a common occurrence. Anyone who has traveled though deep snow country in winter has experienced the snowshoe workout. Snowshoes distribute your weight over a wider area, allowing you to move on the surface of the snow without thrashing and floundering in it. All it takes is some skill, balance, patience, and strong leg muscles.

With today's crew of trail-breakers clearing and marking the way on snowmachines, plus the 2,000 mile Iron Dog snowmachine race (Anchorage to Nome to Fairbanks) traveling the same route, the trail is usually well-packed and marked. With that being said, snowshoes are still required race gear, and a sudden snowstorm will necessitate their use.

Jon has pictured some of his favorite old canine companions to follow him through the drifts toward the ribbon of open trail ahead.

71

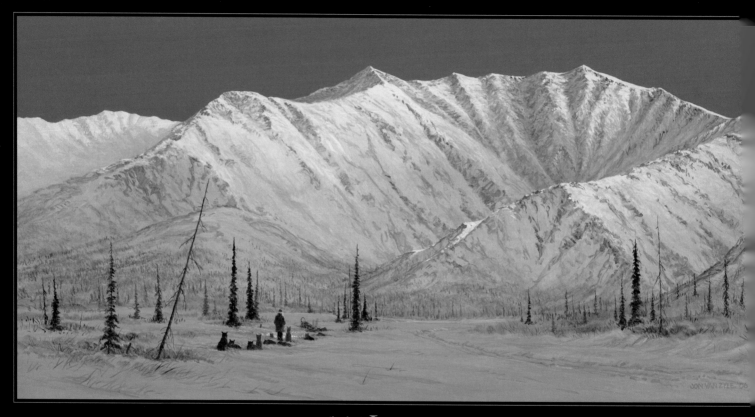

Alaska's IDITAROD *...looking back*
Celebrating 30 years of Official Iditarod poster art by Jon Van Zyle

2006

Alaska's Iditarod ... looking back.
Celebrating 30 years of Official Iditarod poster art by Jon Van Zyle

This poster celebrates Jon's thirtieth year of creating poster art for the Iditarod race. Jon pictures himself as the musher in the image. It's an opportunity to reflect on the trail he's covered both literally as well as artistically. Reaching Nome by dog team is still a monumental feat. More people have summited Mount Everest than have completed the Iditarod race.

By 2006, Jon was becoming less enamored with the heavy schedule of travel for gallery shows and book tours. Instead, we started working with established tour companies who now send their clients to us for an "Alaskan experience." We also started hosting the Iditarod Teacher on the Trail (TOTT) winter and summer conference groups and the Habitat for Humanity Global Village Build groups.

Also in 2006, Jon was the featured artist for the American Bald Eagle Foundation in Haines, Alaska, and we were the Artists-in-Residence for the Wrangell-St. Elias National Park and Preserve. We had a wonderful time exploring the park and doing programs with and for the park rangers. We were also invited by the Catholic Church to do a mural project in the Athabascan village of Ruby. So much for slowing down!

16" x 30" 1,200 printed $48

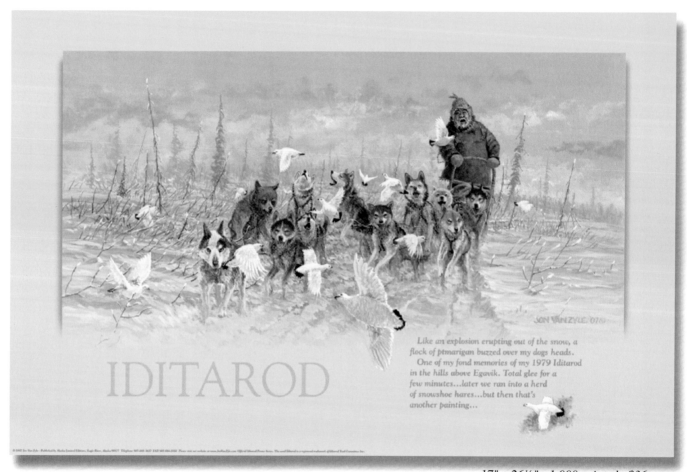

IDITAROD

*Like an explosion erupting out of the snow, a
flock of ptmarigan buzzed over my dogs heads.
One of my fond memories of my 1979 Iditarod
in the hills above Egavik. Total glee for a
few minutes…later we ran into a herd
of snowshoe hares…but then that's
another painting…*

17" x 26½" 1,000 printed $36

74

Above Egavik. Like an explosion erupting out of the snow, a flock of ptmarigan buzzed over my dogs' heads. One of my fond memories of my 1979 Iditarod in the hills above Egavik. Total glee for a few minutes ... later we ran into a herd of snowshoe hares ... but then that's another painting

Egavik is a tiny village between Unalakleet and Shaktoolik located on windy Norton Sound. This poster captures a favorite memory from Jon's 1979 Iditarod race.

Ptarmigan, our state bird, are all white in the winter, and have mottled brown plumage in the summer. Not only are they white, but for further camouflage and insulation, they tend to sleep in the snow. They will fly into a snowbank, leaving no tracks, and nap in cozy comfort ... until disturbed by a sled dog team.

I'm not sure who was more surprised, the birds, the dogs, or the musher! The team was as excited and delighted as kids visiting Disneyland.

I was away at the time of printing, and in my absence, no one else caught the misspelling of the word "ptarmigan" on the poster.

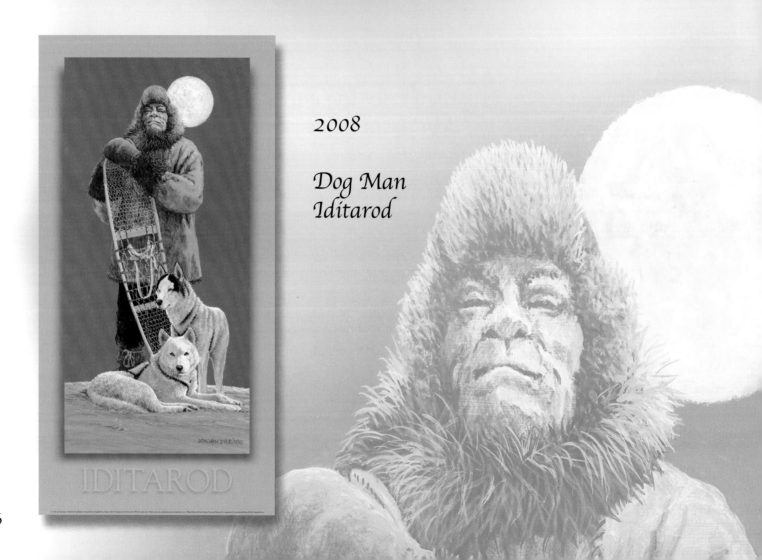

2008

Dog Man
Iditarod

It is quite an honor to be considered a dog man in Alaska. The term could be equated with being a "dog whisperer." The phrase is used to identify a man who truly understands dogs. It appears as almost a psychic ability to communicate with, train, and care for them. Whether running a trapline team or successfully racing an Iditarod team, a well-trained team is an enviable asset.

Jon featured his treasured pair of handmade snowshoes in this poster. The snowshoes were a gift made by George Albert of Ruby. Jon and I still cherish all of the gifts we received from the 2006 Catholic Church mural project we did for the Athabascan village of Ruby.

13" x 24" 1,000 printed $36

77

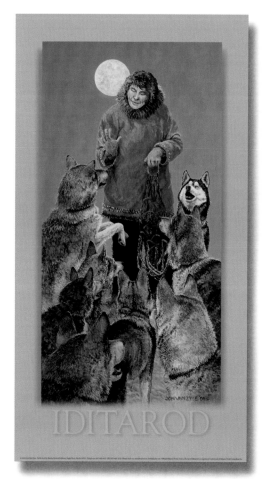

12½" x 23" 1,000 prints $36

2009

Dog Ma
Iditarod

The 2008 poster **"Dog Man"** was a strong graphic image, but I felt it unfairly left women out of the picture. Over the years, women mushers like Mary Shields, Libby Riddles, Susan Butcher, DeeDee Jonrowe and Aliy Zirkle, just to name a few, have also shown consistent skill and understanding of dogs.

I didn't envision this companion poster image mirroring **"Dog Man."** I couldn't see a proud woman with her dogs at her feet. After much discussion, and possibly withholding favors, Jon decided to recognize a woman's more nurturing relationship with her team.

The title is a play on words, **"Dog Ma"** for the mothering attitude, and dogma for the faith-based morals, beliefs and behaviors that guide us through our lives.

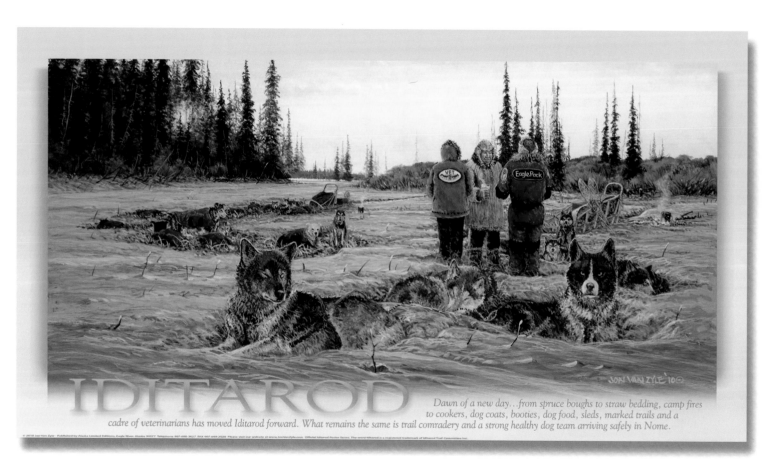

IDITAROD

Dawn of a new day...from spruce boughs to straw bedding, camp fires to cookers, dog coats, booties, dog food, sleds, marked trails and a cadre of veterinarians has moved Iditarod forward. What remains the same is trail comradery and a strong healthy dog team arriving safely in Nome.

13" x 24" 1,000 printed $36

80

2010

Dawn of a New Day.
… from spruce boughs to straw bedding, camp fires to cookers, dog coats, booties, dog food, sleds, marked trails and a cadre of veterinarians has moved Iditarod forward. What remains the same is trail comradery and a strong healthy dog team arriving safely in Nome.

This poster is a study in contrasts, looking at the old ways and the new. Jon is always comparing the way he used to do things to the newest innovations on the trail today. His memories of building campfires, wooden dog sleds and bedding your team on cut spruce boughs are gone. Clean straw is provided at every checkpoint, sleds are high-tech metal contraptions, and modern cookers provide boiling water in under twenty minutes.

He pictured old and new camped together. He wanted to show the contemporary musher bedecked in sponsor patches, but getting permission took time. Eagle Pack Natural Pet Food was first to respond, and it's been a wonderful relationship ever since.

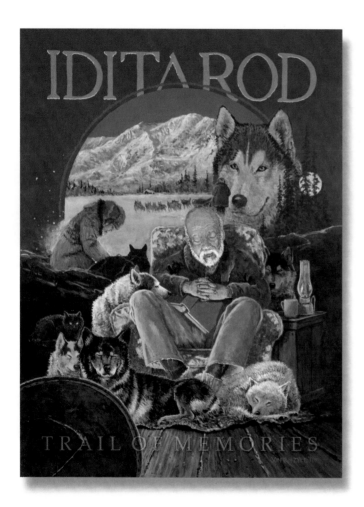

Trail of Memories

Comfortably ensconced in a favorite chair, surrounded by his old friends, Jon finds it easy to doze and dream of the trail. Although he only raced Iditarod twice, he can still describe the trail topography in detail. The experiences were life-changing for him. His memories burn brightly and his art ideas continue to flow.

This poster was created during the time we were involved in a five year long book project. The Old Iditarod Gang, as we call ourselves, worked to collect and record the history and stories from the first ten years of the Iditarod race. Our tome includes over 100 first-person stories, 95 pieces of original art, 416 photographs, all compiled in a 424 page book, weighing over 7 pounds and entitled *Iditarod: The First Ten Years*.

18" x 24" 1,000 printed $36

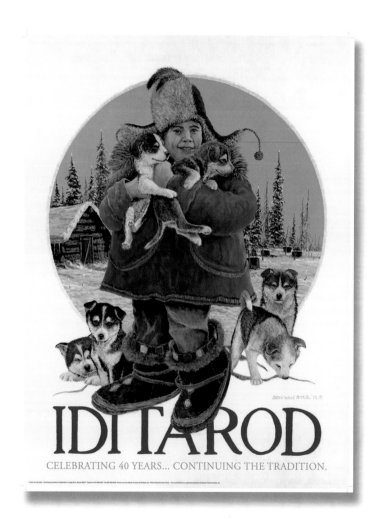

2012

Celebrating 40 years ...
continuing the tradition

18" x 24" 1,000 printed $36

84

In 2012 the Iditarod celebrated its 40th anniversary. Thinking about the things that keep the race going, Jon and I came up with three main ideas. First is money: the continued support of interested sponsors. Second is the continued support of hard-working, dedicated volunteers. Third are the new generations of mushers and dogs. The mushers Jon raced with in the 1970s now have children and even grandchildren continuing the tradition.

We are proud to be long-time sponsors of many mushers, and supporters of both the Iditarod and the Jr. Iditarod Races. We also support numerous other educational mushing programs around the state, country and even the world.

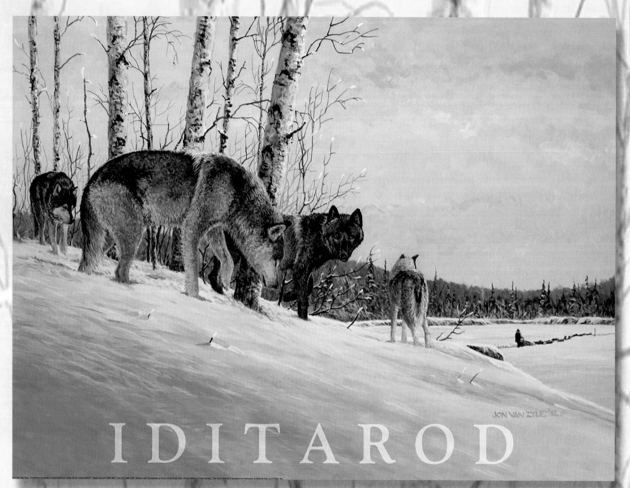

IDITAROD

18" x 24" 1,000 printed $38

2013

On the Trail

This poster recalls the thrill of seeing wolves along the trail. The race traffic is a financial gift to many remote villages and a gift of easy food for wildlife. With so many mushers feeding and snacking their teams along the trail, birds and wildlife can scavenge easy meals in the cold winter.

This original painting was completed earlier than usual and then premiered at an exhibition in Bern, Switzerland, in November 2012. Since the original painting wasn't available for a color comparison when the poster was printed, the colors are more vivid than in the original painting. The color red tends to gain intensity on the press during the printing process.

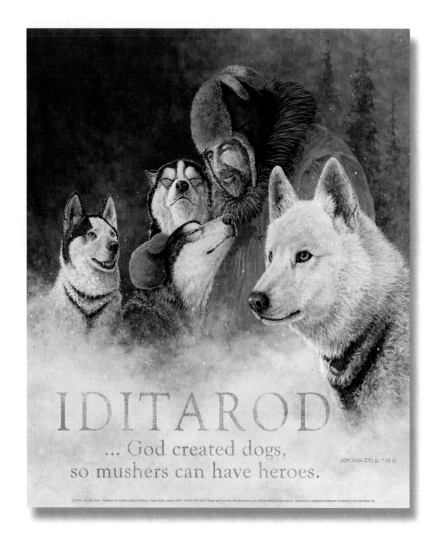

2014

...God created dogs so
mushers can have heroes

18" x 24" 1,000 printed $38

The theme here is obvious, but it was a bit controversial including God with the poster text. Jon never wants to offend his fans, but felt he was entitled to his opinion and collectors could purchase or not, but purchase it they did.

Based on the creation of this painting, Jon produced his first art lesson teaching tutorial for the Iditarod Teacher on the Trail (TOTT) program. Thanks to our ever-present, ever-patient webmistress, Theresa Daily, Jon has entered the age of computers. He even has been known to post on Facebook!

89

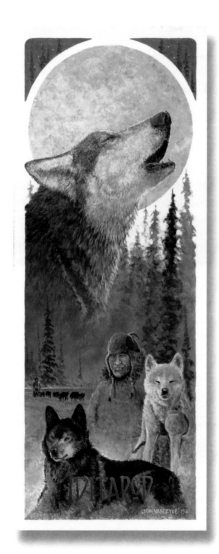

2015

Song of the Trail

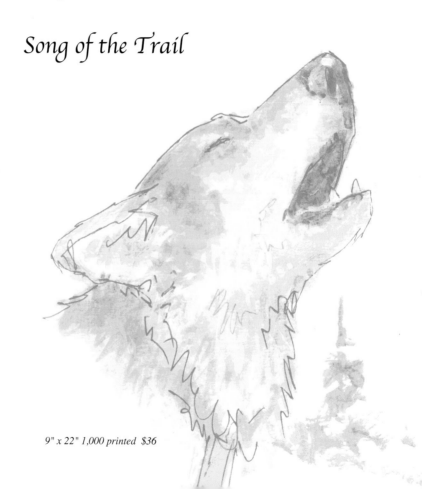

9" x 22" 1,000 printed $36

Taking inspiration from his days as a commercial artist, Jon revisited a more graphic art style for the poster this year. He also changed the format to tall and skinny in response to complaints from collectors about their lack of wall space … they should see our home.

Jon features two of his favorite old dogs in the foreground of the poster. The dark dog is Hardtack. Hardtack was a Joe Garnie dog from the village of Teller, north of Nome. Hardtack was a five time Iditarod race finisher, with four different mushers. One of his finishes was a win with Jeff King. HT, as he was called, was also a cancer survivor. Our kennel was his retirement home, where he had unlimited toys, playmates and freedom. Never having access to so much loot, Hardtack filled his doghouse with so many bones, balls and toys that he had to sleep outside on top of his house.

Saa is the other featured husky. Saa was another big male, but all white. He was a souvenir from Jon's Siberian adventure. After a tough puppyhood in Siberia, Saa relished his Alaskan life. I remember him being such a kind babysitter with our puppies and he reveled in their attention. Saa would race around the yard with a half dozen puppies hanging on his collar. When he had enough of the pups, he'd jump to the top level of the play platform treehouse to catch his breath. It took the puppies a couple of weeks to figure out where he went, and then how to make the climb up to invade the adult's refuge. We have so many fond memories of all of our dogs. We have been truly dog blessed.

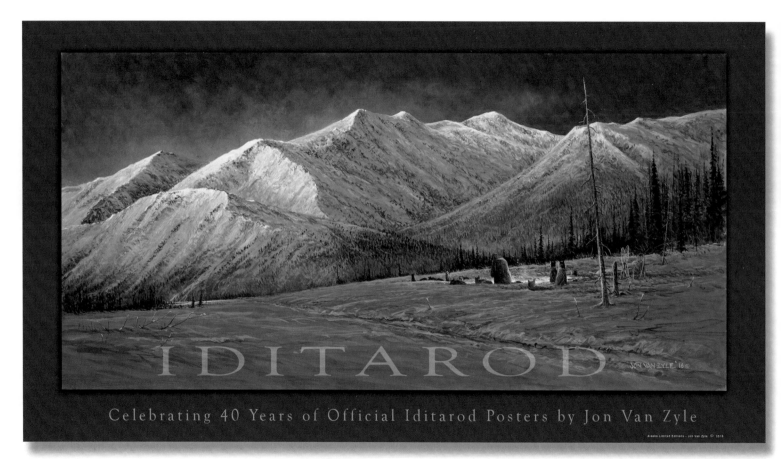

IDITAROD

JON VAN ZYLE 16©

Celebrating 40 Years of Official Iditarod Posters by Jon Van Zyle

Alaska Limited Editions · Jon Van Zyle © 2016

13" x 24" 500 printed $38

Moonlit Trail
Celebrating 40 years of Official Iditarod Posters by Jon Van Zyle

With moonlight warming the night, Jon has picked a spot to stop for a late supper. So many decisions come into play when choosing a spot to camp. Is there any dry wood for a fire? How about clean snow to melt for water? Is there a place to get out of the wind?

Just as in choosing a spot to camp, Jon also makes a multitude of decisions creating his paintings. The challenge is to balance the subject matter, the color, the light, and the movement while still telling a story.

Speaking of choices, another choice for this year was to limit the number of posters being printed to 500. Facing dire economic times, art is a luxury that is quickly cut from the budget. Consequently, many of the art galleries that have long carried Jon's work are no longer in business. Knowing the popularity of Jon's posters, several other race sponsoring corporations now offer free photo posters at the pre-race banquet or other race events: Jon still has a strong following, but the challenges to make a living as an artist get tougher all the time.

93

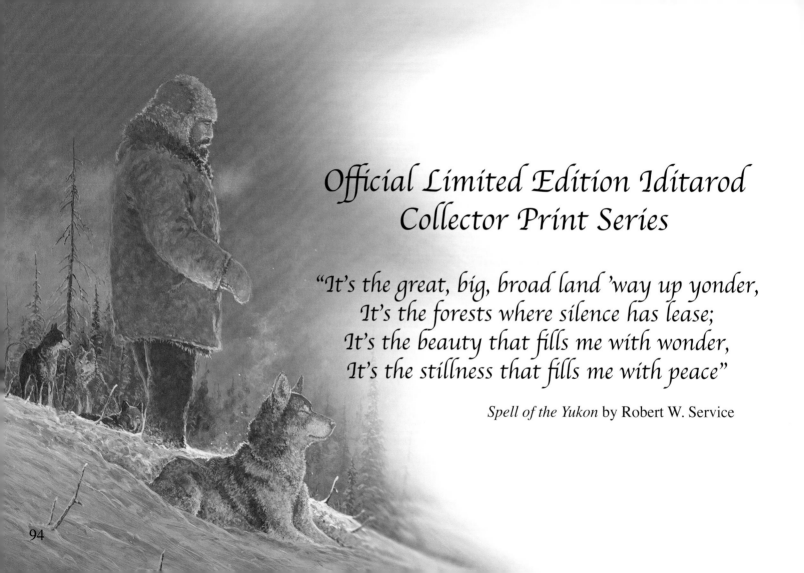

Official Limited Edition Iditarod Collector Print Series

"It's the great, big, broad land 'way up yonder,
It's the forests where silence has lease;
It's the beauty that fills me with wonder,
It's the stillness that fills me with peace"

Spell of the Yukon by Robert W. Service

Robert Service's words echo through Jon's art. His ability to capture the essence of Alaska, to roll poetry and storytelling into an image touched a chord in so many fans.

I think his popularity came at a time when photography and TV coverage of the Iditarod Race were just starting to reach the rest of the world. Black and white photos in the newspaper, or fleeting images on television didn't have the staying power of artwork that could hang on your wall and be enjoyed for years.

One of Jon's most astonishing skills is his ability to mentally juggle multiple projects. I never know if he is designing the next Iditarod art, illustrating another book, creating new products, or thinking about projects to benefit our community.

At any time we could be working with the University of Alaska, Habitat for Humanity, our military, Boy Scouts, Girl Scouts, Alaska's Jewish Community, Anchorage Philatelic Society, junior mushers … or, heaven help me, all at once!

I point this out because many fans assume Jon only creates Iditarod art. As important and as close to his heart as the race is, it's only a small part of his annual art production. When taken in context with his art career, it makes his commitment of forty years to the Iditarod race all that more amazing.

For the first time we have assembled the Official Iditarod collector prints starting with **"Close Call"** in 1983. We've listed the size of each print, the number of prints printed in the edition, and the original cost of the print. Jon still personally numbers and signs each print he produces.

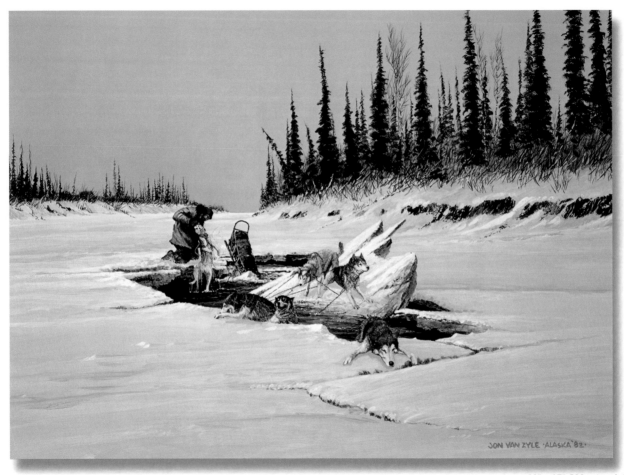

JON VAN ZYLE ·ALASKA·'82·

13" x 17" 500 printed $48

1983

Close Call

Jon introduced his Iditarod print series in 1983 with a limited edition of 500 prints. The term "limited edition" means that once the edition of prints are sold out, it won't be reprinted. Occasionally, years after the print sells out, the image or a section of it may appear on a note card, T-shirt or coffee mug. Out of respect for the original print buyers, Jon will change the size or format.

"Close Call" is a haunting memory of a heart-stopping incident. When traveling on river ice or sea ice, you never feel completely comfortable. When the ice broke, it happened so suddenly that there was no time to worry, just react. Ice water is your enemy, so once you pull your dogs out of the water, you roll them in the dry snow to soak up the moisture. If the musher gets wet, he builds a fire to warm up and dry off. If the dogs get wet, their natural instinct is to shake dry, then roll. Then as quickly as possible, you get the team moving down the trail to warm them up again. Jon said only then could he allow himself to think about what just happened and the possibly horrible consequences of the event.

Bashful is pictured as the dog Jon is rescuing. This first print sold out before the race was over.

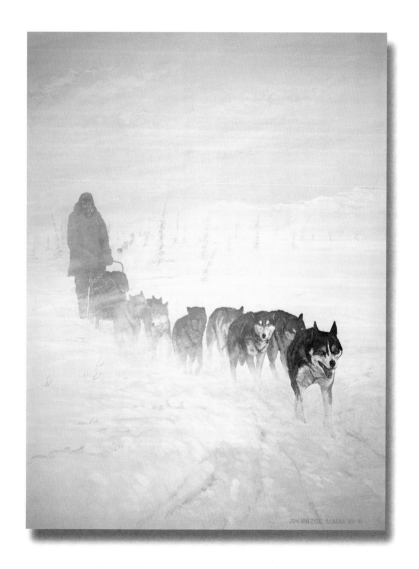

1984

Taking Turns

13" x 17" 500 printed $50

Trudging through deep snow, wearing awkward snowshoes, is a whole body workout. Your leg muscles scream. You quickly work up a sweat in your heavy winter clothing, and then risk frostbite or illness when you strip away the layers.

A heavy snowfall or windblown drifting snow can obliterate a trail and halt even the strongest dog team. If you are lucky enough to have traveling companions to share the arduous task, you're lucky enough!

In the early years of the race, trail etiquette dictated that you shared the work. Stories persist, however, of a few teams doing long hours of hard work breaking trail, only to be passed by a well-rested team coming from behind. Jon painted his dog Jack as the hardworking leader.

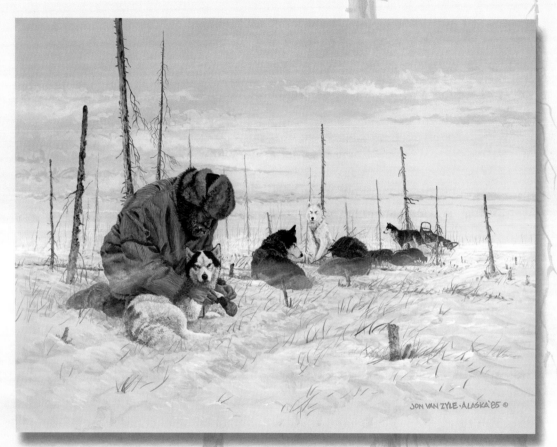

JON VAN ZYLE · ALASKA '85 ©

1985

Deserving the Best of Care

Dog care, especially foot care, is still foremost on a musher's mind. If your team has sore or injured feet it won't travel very far. As he often does, Jon has pictured himself, but this time in the Farewell Burn area. He's putting booties on his dogs Pikaki and Neeka before heading out on the rough trail.

13" x 17" 500 printed $60

For you fashionistas, or those with a love of shoes, the progression of dog bootie design is quite interesting. Mushers have always tried to protect their dogs. Fur or padding was added to harnesses, blankets or coats were used for cold weather, and foot protection was designed for rough trails.

I've seen some early canvas and leather creations designed by the military for sled dogs used in World War II. They look very sturdy, but not flexible, comfortable or practical.

Jon used to use old denim for booties, with hockey tape wrapped around the dog's wrist to hold it on. The trouble with that was if it was too loose, it fell off, and if it was too tight, it restricted circulation and the dog's wrist and foot would swell.

Nowadays, the best booties are constructed of sturdy pack cloth with elasticized Velcro closures. They come in a myriad of colors and cost about $3 per bootie. $3 × 4 booties per dog = $12 per dog. Multiply that by 16 dogs = $192 per team per 50 miles. Then consider there are 1,000 miles or more of race trail. There's certainly a need for deep pockets or race sponsorship!

The years may change, but the care of your dogs is still the first priority.

Each year Alaska Airlines presents the Leonhard Seppala humanitarian Award to the musher giving their team the best care. This highly coveted award is judged by race veterinarians along the trail, coupled with the condition of the team at the race finish. Leonhard Seppala was a legendary musher known for his training skills and dog care, a true "dog whisperer."

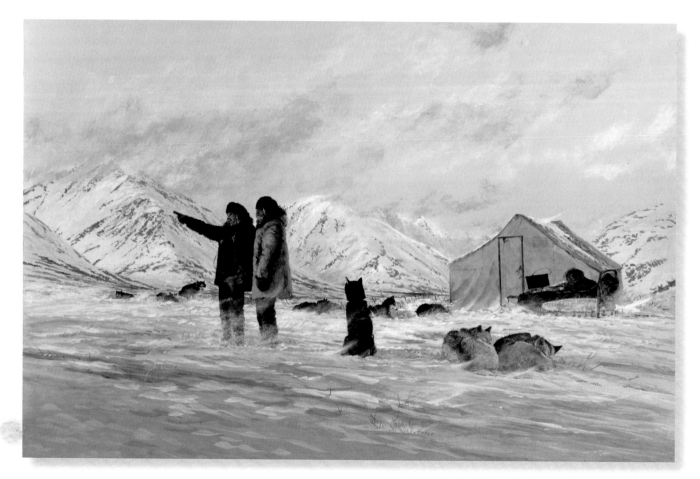

102

13" x 17" 500 printed $70

1986

Start of a Long Friendship

In 1976, his first Iditarod, Jon stopped his team above Rainy Pass for a snack and a rest. He had stopped at a deserted sheep hunter's tent camp to take advantage of the limited shelter it offered.

As Jon was preparing to leave, another musher pulled in. He introduced himself as Dennis Corrington, and they talked about the usual topics: weather, trail conditions and an approaching storm. After their break they decided to travel through the pass together. As sometimes happens, they realized that their teams traveled at about the same speed and more importantly, so did their questionable sense of humor! Whether it was Jon's female leader being in season, the flask of apricot brandy, or the trail high jinks, they traveled together for the next two weeks. Finishing in Nome just seconds apart sealed the friendship. Now forty years later, Jon and Dennis still keep in touch.

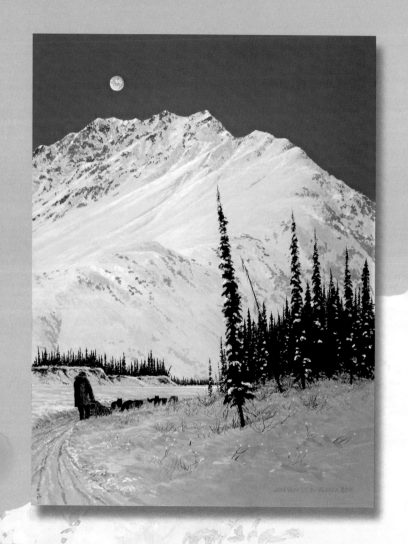

1987

Into Hell's Gate

13" x 17" 500 printed $70

Once mushers reach Rainy Pass, the highest point on the Iditarod Race trail at an elevation of 3,160 feet, it's all downhill from there.

In the first years of the race, the trail was routed through the headwaters of the Kuskokwim River, through Ptarmigan Pass, and then down through the aptly named Hell's Gate.

In 1977, that trail was deemed too dangerous and now teams travel through the Dalzell Gorge. Most mushers still consider this part of the trail a nightmare. It is miles of steep, twisting, tight trail with hairpin turns, overhanging branches, and it's edged in sled-grabbing scrub willows, if it is bordered at all.

By the time they reach the next checkpoint at Rohn, every musher has a story to tell. Just seeing the broken sleds, black eyes and broken body parts says it all.

JON VAN ZYLE "ALASKA '88 ©

1988

Beyond the Unknown

13" x 17" 500 printed $70

Somewhere on
the Yukon River of Jon's 1979 race, between
Kaltag and Anvik, he had a strange experience.
He remembers passing an island on his right
side as he traveled downriver at night. At first he
heard the murmur of voices, but could see no one
around. The voices grew louder, and he could
hear laughter, conversations and clapping as he
passed the island. Then the noise faded away.

Years later at an art show, a Catholic
Priest he met told Jon he passed Massacre Island
and only a privileged few people hear the voices.

Jon has said he was wide awake and not
hallucinating, and that others have also heard the
voices … that's his story and he's sticking to it!

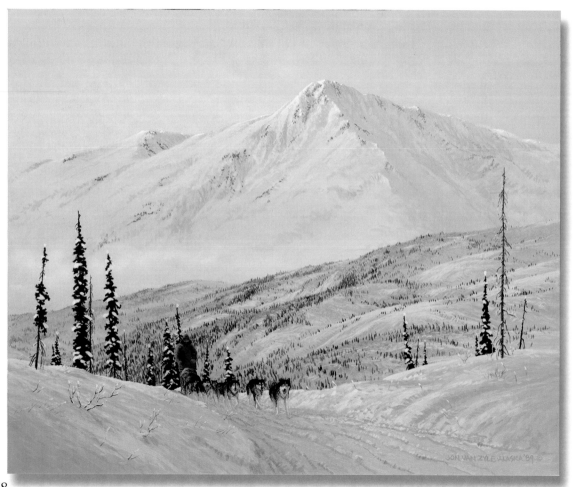

1989

Into the
Pass
and
Shanda

21" x 17" 580 printed $115

108

In 1989, Jon started a new six-year series featuring a print duet pairing a favorite dog with a related trail image. This was a suite of two prints sold together.

Shanda was a favorite leader who loved the mountains and the climb to get there. She was happiest traveling through the Alaska Range and the first section of the race trail. Jon paired this tough little leader, who was all heart, with the mountains she loved.

"Into the Pass" captured the feeling of Rainy Pass and Ptarmigan Pass, the highest elevations on the trail.
This print also started Jon's stint working with Minnesota-based Voyager Arts, another big publishing company.

9" x 12"

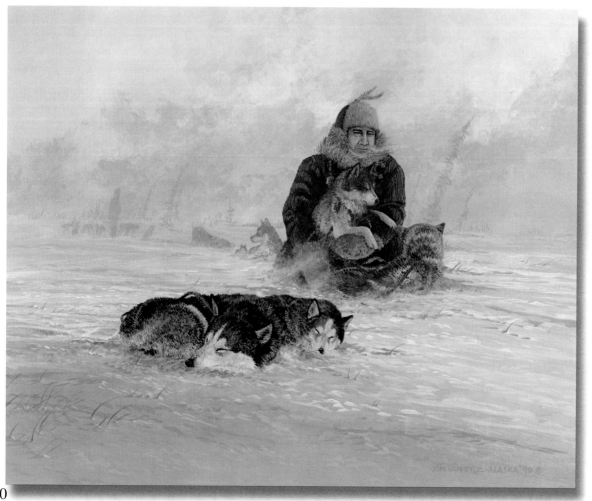

1990

*Quality
Time
and
Pikaki*

21" x 17" 580 printed $115

Little Pikaki might be one of Jon's favorite dogs ever. She was named after the small, white, fragrant Hawaiian flower. She and Jon were mentally in sync. Jon claims all he had to do was think something and Pikaki was ready to do it. She had an adventuring spirit and wasn't afraid to break trail to get there.

The companion print, **"Quality Time,"** refers to the special time Jon gave each dog every day. After a stretch of bad trail, or the evening meal, Jon would spend time with each dog, massaging sore muscles or sore feet and discussing the events of their day. I'm sure this personal contact was reassuring to the dogs and probably bolstered Jon's spirit and mood too.

9" x 12"

111

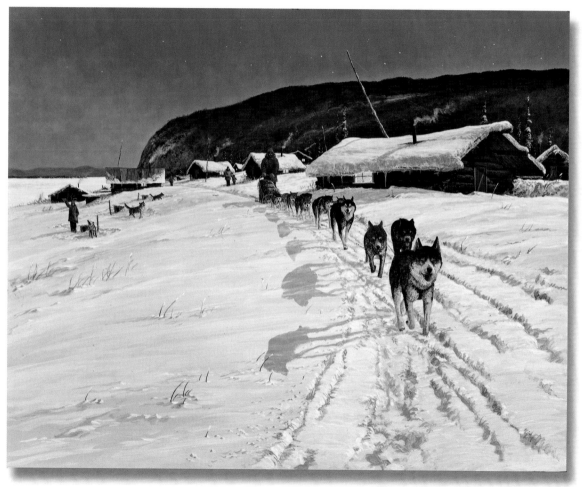

1991

*Trail Out
of Ruby
and
Bobo*

21" x 17" 580 printed $125

Bobo was a house dog, a companion dog, bought as a puppy from Snowshoe Kennel in Oregon. Bobo was a Siberian Husky, as are all of our dogs. He grew into a big dog and a best friend to Jon. Bobo accompanied Jon on fishing and camping trips in the summer and sled trips in the winter. Bobo ran in wheel position, which was closest to the sled … and to Jon. Bobo also had a great appetite. This is of the utmost importance to most mushers, because a dog who isn't finicky about food and will always eat on the trail is a healthy, happy dog. I have to say that Jon is a good eater too, and in an eating contest, my money would be on Jon!

"Trail Out of Ruby" is the companion print and it recognizes his fondness for the Athabascan Village. Ruby is located on the banks of the mighty Yukon River. Nicknamed "the jewel of the Yukon," Ruby is still home to good dog men, Don Honea and Emmitt Peters. Emmitt, also known as the Yukon Fox, won the 1975 race, as well as an amazing string of top 10 finishes.

9" x 12"

1992

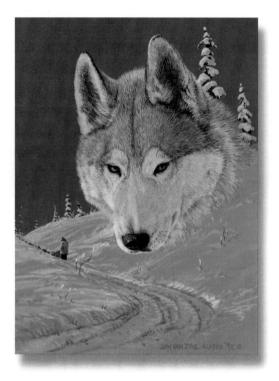

9" x 12"

Trail Break and Belle

Being blind in one eye didn't seem to handicap Jon's fast little leader, Belle. She was hard-headed and sure of herself in harness, but shy and cautious around people. She had been originally trained for sprint racing and ran in the 1978 Anchorage Fur Rendezvous. Jon changed her sprint training to distance running and she made his Iditarod team in 1979.

Jon's favorite story about Belle took place in McGrath. As he was heading into town to find the official checkpoint and a place to bed down the team, Belle suddenly pulled into a driveway.

Jon stepped on the sled brake and called his leader to turn back onto the road. Once they were heading in the right direction, Belle again swung the team into the drive. Jon stopped the team and called her back, finally convincing her to follow the road into town. Jon reached the checkpoint and checked in. When he asked where he could stay, the checker said to head back down the road to the driveway his leader chose!

The companion print, "**Trail Break,**" captures a rest stop on the trail. Checkpoints range from twenty to ninety miles apart, which may not coincide with the needs of your dogs, so there are bound to be breaks on the trail. In the early days before the use of methyl-alcohol cookers, mushers had to take the time to gather wood and build a fire. It was a time-consuming process and was part of the reason the early Iditarod races were taking about a month to complete. Today teams are finishing in eight to ten days, depending on the weather. Even the last place teams are finishing in fewer days than the early winners.

It may have been slower, but there was something special, maybe comforting, about stopping in a beautiful spot and camping by a cheerful fire.

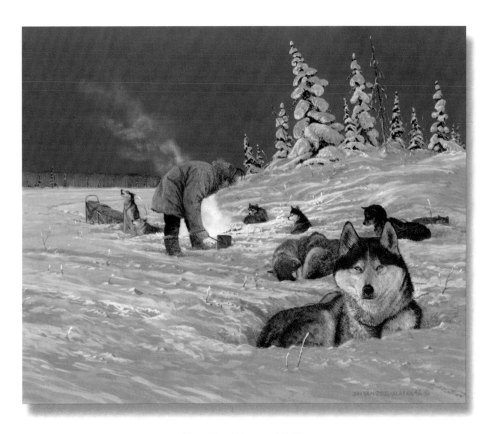

21" x 17" 580 printed $125

1993

Trail into the Mystic
and
Bashful

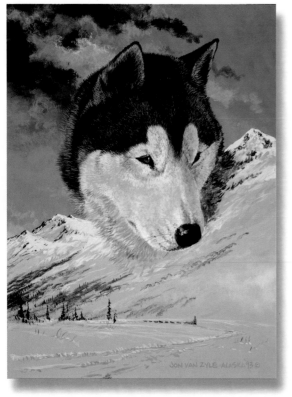

9" x 12"

Bashful was a beautifully built Siberian Husky from the world renowned kennel of Earl and Natalie Norris in Willow, Alaska. Bashful was a sweet but very shy dog who loved Jon. Jon loved her because she was a dream Iditarod dog. She was an extremely fast trotter, as well as an honest, hard-working and highly food-motivated girl. Bashful was pure drive on the trail, and a good camper when he stopped. Teaching young dogs to understand how to run is no problem since they do that naturally. The camping part, knowing when and how to rest is a bit trickier. The first few overnight camping experiences leave you feeling like you've spent the night with sixteen sugared-up youngsters at their first sleepover. No one gets any rest.

The accompanying print, **"Trail into the Mystic,"** was inspired by the lyrics to an old Van Morrison song, "Let your soul fly into the mystic." Traveling cross-country in Alaska is a spiritual experience. The magnitude of the mountains, the vastness of the big rugged land, it leaves you feeling so tiny and insignificant. Yet you and your dogs move mile by mile across the wilderness. Somehow you cope with every kind of weather condition and obstacle Mother Nature can throw at you. If the adventure doesn't kill you, it forges an emotional and spiritual bond with the land that leaves you feeling ten feet tall and able to handle anything.

Music has always accompanied the mushers. On long, easy stretches of trail, you find yourself humming or singing to your team to celebrate the joy in your heart. With today's high-tech devices, mushers can carry and access a whole playlist to suit their mood. Music can lift your spirit, and if you are upbeat and happy, your dogs pick up on it and they'll run better too.

21" x 17" 580 printed $125

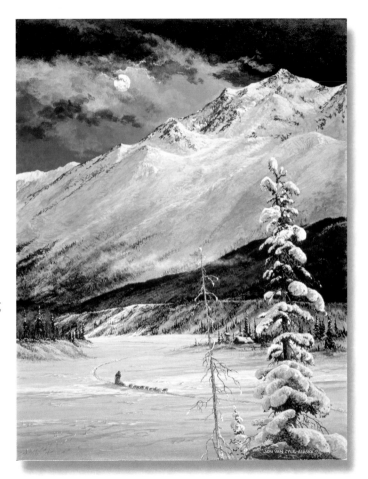

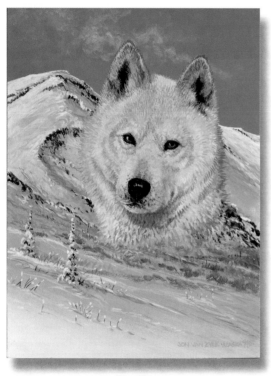

9" x 12"

1994

Sharing
and
Smokey

Smokey was another Siberian Husky from the Earl Norris Kennel. Jon remembers Smokey as a hardworking dog who was always upbeat and happy. He was beautifully built and moved down the trail with an easy, smooth gait.

Rather impressive himself, Earl Norris completed his first Iditarod race in 1985. Earl was 65 years old and finished in 31st place. In 1984, Earl mentored Norwegian musher Kari Skogen to a 35th place finish and a family membership as his daughter-in-law! As of 2014, granddaughter Lisbet Norris is continuing the tradition of running the Iditarod with Siberian Huskies.

The companion print, **"Sharing,"** features a familiar-looking musher breaking trail somewhere in the mountains of the Alaska Range. Jon was proud of his ability to train his team to patiently follow behind him. Walking through deep snow in snowshoes is difficult enough without having your lead dogs catch you behind the knees with their neckline and take you down. Once you've stamped down a firm trail, it's much easier for your dogs to get through.

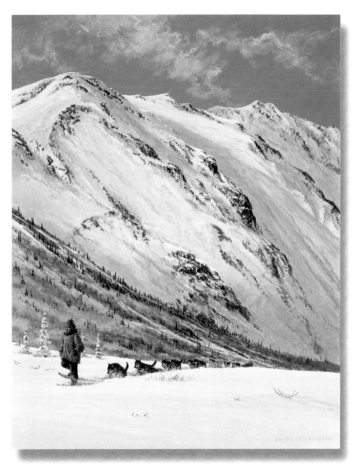

21" x 17" 580 printed $125

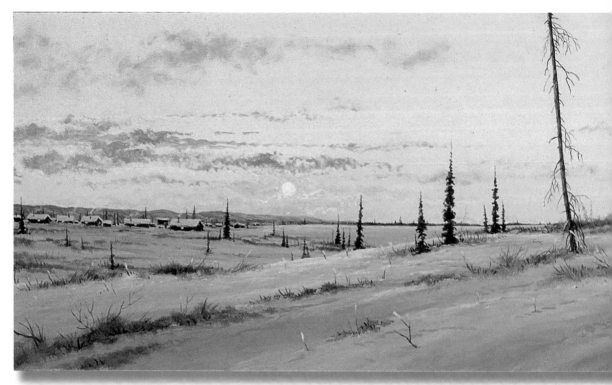

 This print starts a new series theme with each print being accompanied by a frameable token to enhance the print's story. This year also marks a change with Jon now being published by Hadley House of Minnesota. The print market was still near its peak and large format prints were the style. In today's economy, the cost of matting and framing a large print would set you back significantly. The scenery Jon depicts in the print is similar to what you'd see leaving the village of Unalakleet, located on the Norton Sound and heading into the Blueberry Hills.

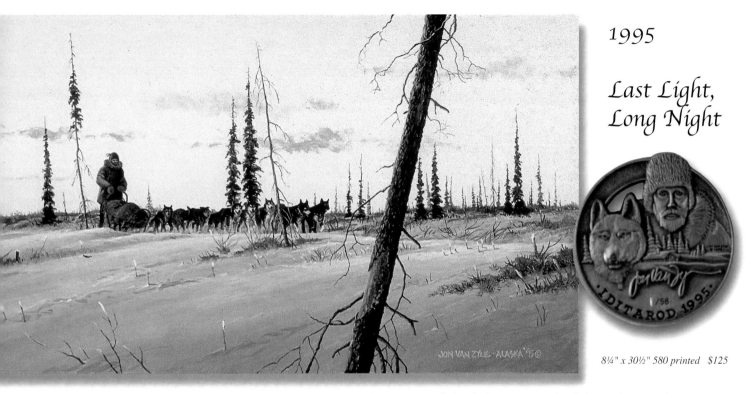

JON VAN ZYLE · ALASKA '95 ©

Last Light, Long Night

8¼" x 30½" 580 printed $125

By this time in March, you can feel the lengthening hours of daylight. Long colorful sunrises and sunsets celebrate the start and finish of each day. Beautiful as they were, by this point in Jon's race, he was dreading sunsets because it meant another long, cold night lay ahead.

The token that went with this print was a numbered pewter disk with a musher and a dog, stamped "Iditarod 1995."

121

1996

Catch Me
if You Can

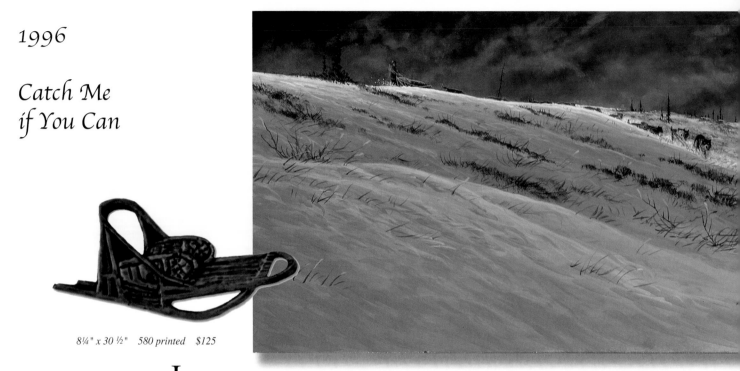

8¼" x 30 ½" 580 printed $125

In 1977 the race trail started alternating to a southern route in odd years and the northern route in even years. This option lessened the pressure on tiny remote villages to deal with the influx of mushers and volunteers from the race.

Jon and his team departed the ghost town of Iditarod, the halfway point on the southern route, and were heading to the village of Shageluk during the 1979 race.

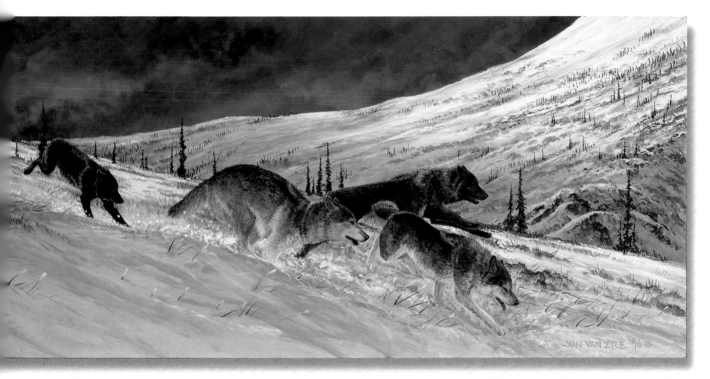

He and the team were working their way through a series of windy hills on the 65-mile run. Lost in thought, Jon realized that his speed was suddenly increasing and his dog's ears were pricked forward at full attention. As they accelerated up a hill and crested the summit, Jon caught sight of six or seven wolves racing down the trail ahead of them. They chased the pack for about a mile before the wolves dissolved into the brush beside the trail. The excitement of the encounter left Jon and the dogs moving on adrenaline for several more miles.

The token with this print was a small replica of a dog sled with snowshoes in the sled basket.

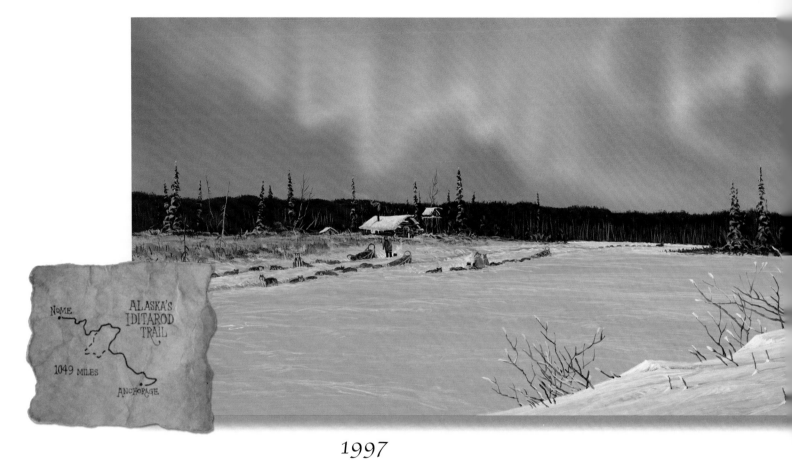

ALASKA'S
IDITAROD
TRAIL

NOME

1049 MILES

ANCHORAGE

1997

In the Silvery Light

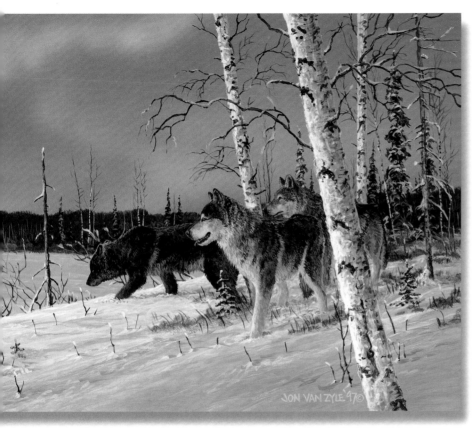

7½" x 23" 580 printed $100

Silver signifies the twenty-fifth anniversary and Jon used that as his inspiration to recognize Iditarod's twenty-fifth anniversary. This print captures all of the elements that race fans love about the Iditarod and Alaska.

The wolves draw you into the print as they watch the checkpoint from the shadows of the birch trees. Across the frozen river, ghostly, silvery light brightens the blanket of snow. Warm light shines from the checkpoint window, a beacon to cold weary mushers still on the trail. Overhead, the Aurora Borealis dances in celebration of another year on the trail.

The token with this very popular print was a small Iditarod Trail map, drawn on brown, distressed paper with a deckle edge. A deckle edge was the decorative textured edge common in handmade paper made before the 19th century. Once paper was made by machine, it was cut to specific dimensions, eliminating the decorative edge.

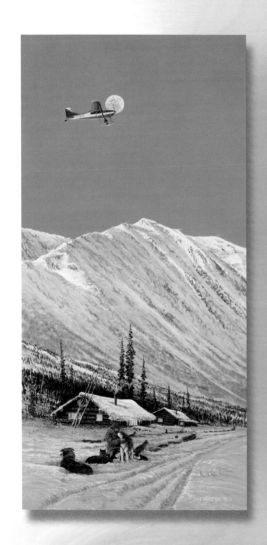

1998

Above and Beyond

10" x 20" 580 printed $100

This print offers a different view of Rainy Pass Lodge. It's dedicated to the Iditarod Air Force pilots who fly above the trail and who go above and beyond the call of duty to deliver race personnel, provisions, veterinarians, and volunteers to checkpoints all along the trail.

Because of its proximity to Anchorage, about 188 miles, there are plenty of small airplanes and snow machines viewing the race. Many tourists and race fans can visit in a day trip and get a peek at "wilderness" and the mushers on the race trail. Alaska's road access ends at the race restart in Willow, so snow machine or airplane are your choices for following the race. Flying the race trail is possible in a small airplane with a good pilot. It's expensive and be prepared to be patient about weather delays and to spend your nights camping or staying in simple cabins with primitive plumbing. It will be a big adventure for you too.

The token with this print was a patch of airplane fabric from a damaged Super Cub that was being recovered. The red fabric is stamped "Iditarod Air Force."

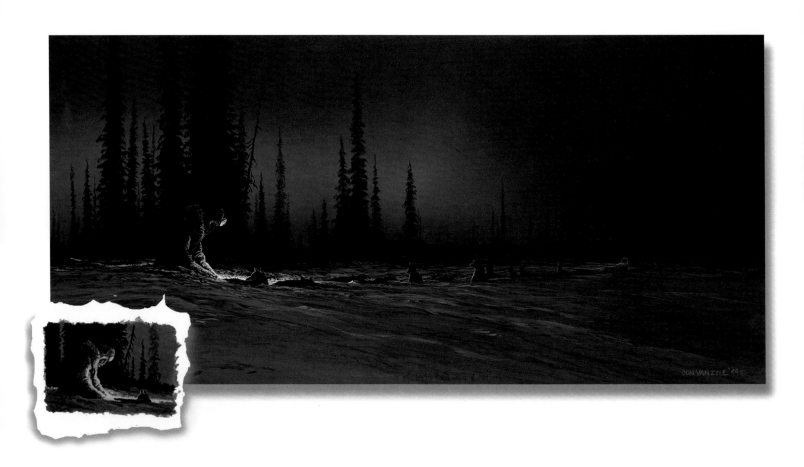

11" x 23½" 580 printed $115

1999

Kindle

"Kindle" was an uncharacteristically dark painting. Jon wanted to capture the isolation a musher can experience in the dark, cold, inhospitable wilderness. The world shrinks to the area of light from your headlamp. Only your dogs, your teammates, your lifeline to the next checkpoint, are bathed in light and are the focus of your attention.

Until you spend your life running dogs long distances, you can't imagine how attuned you become to every nuance of your team, and how attuned they are to you. To be able to work in harmony and trust is the special bond to which every dog musher aspires.

Jon picked the title **"Kindle"** to bring warmth and light to the painting, to hopefully spark a relationship with the viewer.

The token with this print was a small cameo print of just the musher, printed on paper with a deckle edge.

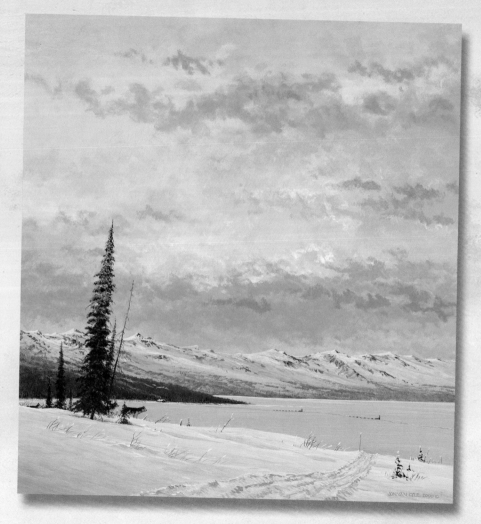

130

17" x 15¾" 580 printed $120

2000

Ahead of the Past

Jon captures the last burst of sunlight in the tall spruce tree as the day fades away and the teams continue down the trail. Sometimes he philosophically ponders the changes in the race and the state he loves so well. Thankfully, these moments pass, and he can resume painting. It is interesting to consider that the teams still traverse the trails from the past with the insight and technology of the future.

Alaska may still feel like wilderness to newcomers to our state. For those of us who have been here for awhile, we see so many changes. It seems as though every buildable lot now has a home or business on it. Most Alaskans don't usually lock their homes or vehicles, but the huge influx of drugs and crime are rapidly changing that. Our main sources of income have been fishing, oil, timber and mining, and all are in jeopardy. We are all going to have to make changes to protect what we love about our state and our earth.

The token with this last in the series print was a miniature of the wolf and the spruce tree printed on metal.

131

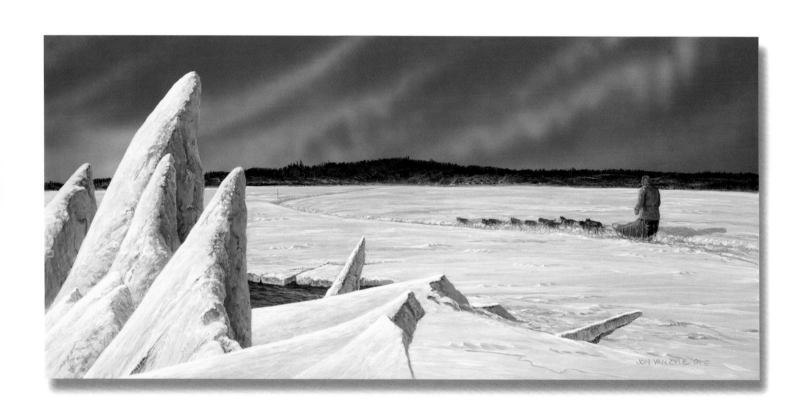

11" x 23¾" 580 printed $125

2001

On the Yukon

The Yukon and other rivers are the mainstays of travel in remote areas. As opposed to bushwhacking through heavy brush or slogging across wet tundra, travel by boat in the summer or snowmachine or dog team in winter is much easier along the river highways of the north.

Jon has memories of traveling to Galena with Northern Lights dancing overhead and the bright lights of Galena glowing ahead of him. The good news was the checkpoint was just ahead … the bad news was that it took forever to get there. The bright lights from the military base make the town a beacon for many, many long miles.

2001 marked our first joint art exhibition in Europe. Our first venue was in Stäfa, Switzerland, then at the Deutsches Röntgen-Museum in Remscheid, Germany. It's a pleasant surprise that so many Swiss and German people visit Alaska and welcome us to our shows in their country.

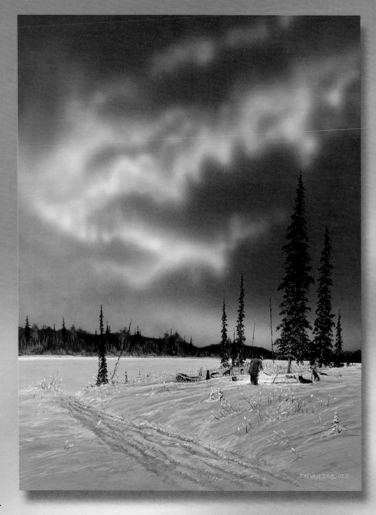

18" x 24" 580 printed $135

134

2002

Traveling Light

This is another title with multiple meanings. **"Traveling Light"** references the undulating auroras that serpentine through the night sky. They don't appear every night, but for mushers who spend a tremendous amount of time outside, the lights are a nice diversion on a long, cold night run. The title also refers to the ability to streamline your packing by taking it down to the bare necessities. Traveling light is an attribute for swift travel, but a risky gamble when things go wrong.

Northern Lights often appear in Jon's winter paintings. He usually chooses his subject matter and paints what he wants. That said, he is also a business man and he listens to the requests from fans, art distributors and gallery owners. It's one thing to paint pretty pictures, it's quite something else to make a living from your art.

2003

Welcome Rest

8½" x 17¾" 500 printed $110

While enjoying the lengthening daylight and sunshine in March, Jon got to thinking about his feelings after the race was over. So much dreaming, planning, training and preparation happens before the start, but what happens after the finish?

Jon said there is pride and joy in accomplishing your dream, then the huge let down of it being over. There is a transition from every moment spent with your dogs to the world of family, work and bills. There is time for rest and reflection. Time to ascertain what ideas and schedules worked and what can be changed and improved for next time. And, you know, there usually is a next time.

The sign on the cabin door reads "Cami," an old Alaskan/Eskimo greeting meaning "welcome" or "hello."

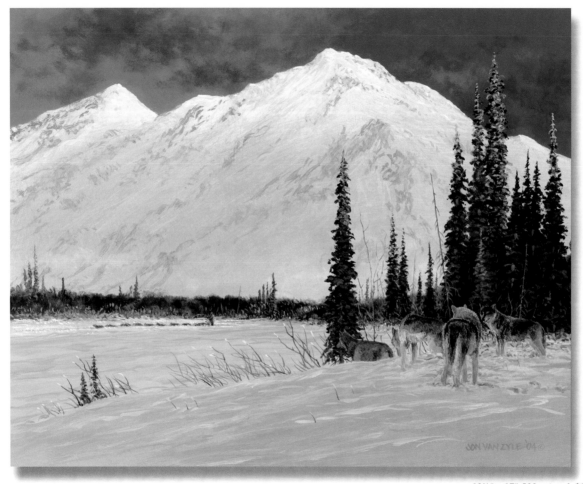

13½" x 17" 500 printed $120

2004

Shadowing the Trail

In the print **"Shadowing the Trail,"** Jon captured fond memories of a good run along the sunny side of a frozen river. Bathed in the warmth of rosy alpenglow light and shadowed by rugged mountains and curious wolves, what's not to like?

Many people question why mushers subject themselves to the cold, the wind, the work and the lifestyle. There are many answers, but most revolve around the ability to adventure with your dogs and the draw of wild places. Sled dogs seem to have an insatiable desire to see new country. They transmit their desire and wanderlust to you, and you become infected by their curiosity to see what's around the next bend or over the next hill. You stop taking trips and start making journeys. As is often said, a journey of 1,000 miles starts with the first step, and your first husky!

8" x 16½" 500 printed $130

140

2005

The Run/Rest Schedule

Who let the dogs in! Mushers consider their dogs as working athletes, but also as family, and the dogs know how to get comfortable if given the opportunity.

In this print, Jon poked a little fun at the serious schedule mushers formulate for the race. The goal is to balance the hours of strenuous activity running with the much needed hours of recuperative rest. Our dogs happily posed for this print, requiring many hours and days of sofa time. I was amazed at the detail Jon achieved in painting the miniature Iditarod posters that he added to the background. This print was not only a hit, it rocketed to the top of the charts with a bullet! (Sorry, it's an old Rock 'n' Roll phrase from my misspent youth.)

An interesting aside is that at this time, there are studies being made that focus on trying to understand the sled dog's amazing recuperative abilities. Researchers hope it could benefit the performance of our military soldiers and human athletes.

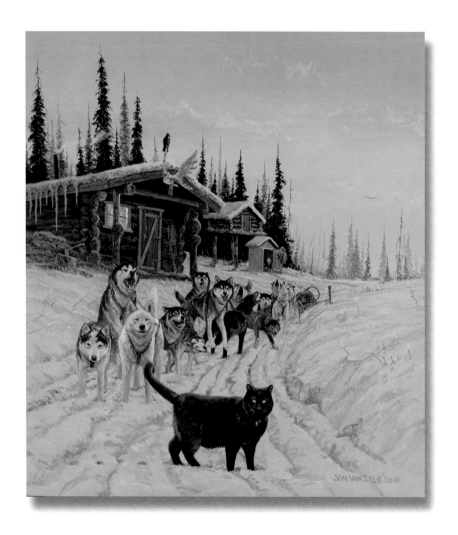

2006

Catastrophe

16" x 18" 500 printed $130

Jon painted **"Catastrophe"** as an acknowledgment to mushers for the years of dedicated training it takes to run the race. So many muddy, scary, dangerous, terrifying and humorous things can happen during 1,000 miles of training runs. Most mushers are not professionals and must balance making a living, raising a family and their sled dog addiction into every 24-hour day. It takes tremendous dedication, lots of patience, and most importantly, a sense of humor to make it work.

Jon chose to highlight the humor aspect in this print. He has painted our guest cabin, our outhouse and our wonderful old black cat Dickens. Dickens' philosophy about dogs, or anything distasteful, was if you don't make eye contact, it doesn't exist. The musher is in the outhouse for a last minute pit stop, the team is anxious to go, the sled has flipped over, lines are getting chewed, and it's about to become a cat-astrophy!

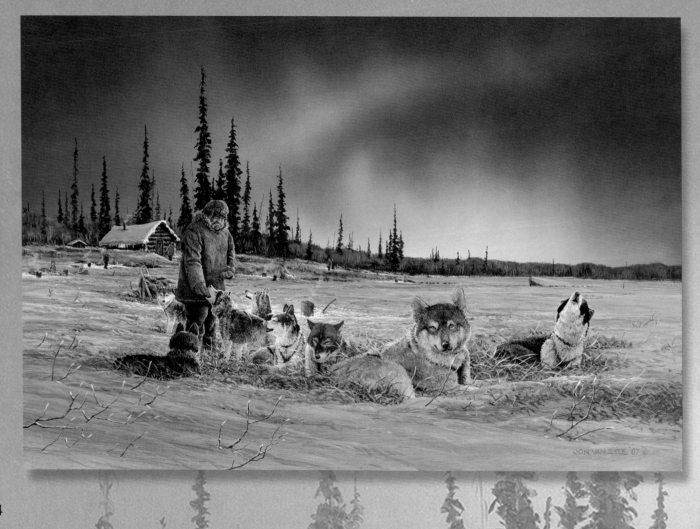

2007

Northern Lights

It's nighttime at a checkpoint along a river. The activity of arriving and departing dog teams flows constantly around the checkpoint, just as the river does in the summer.

The familiar looking musher in the foreground is treating his team to bedtime snacks. The rich, frozen chunks of salmon are high in protein and moisture content needed by the dogs. It's estimated that Iditarod race dogs consume about 11,200 calories per day while racing, compared to about 2,500 calories a day while at home. Their diet is a mix of a quality dry food and then supplemented with a variety of meats, fish, and fats.

Jon's team is nestled in their fresh, summer-scented straw, and can dream sweet dreams under the dancing Northern Lights.

Years ago, Alaska Airlines ran a very popular ad campaign honoring sled dogs. Ads and T-shirts read, "The best long distance runners eat raw meat, run naked and sleep in the snow."

12¾" x 19½" 500 printed $125

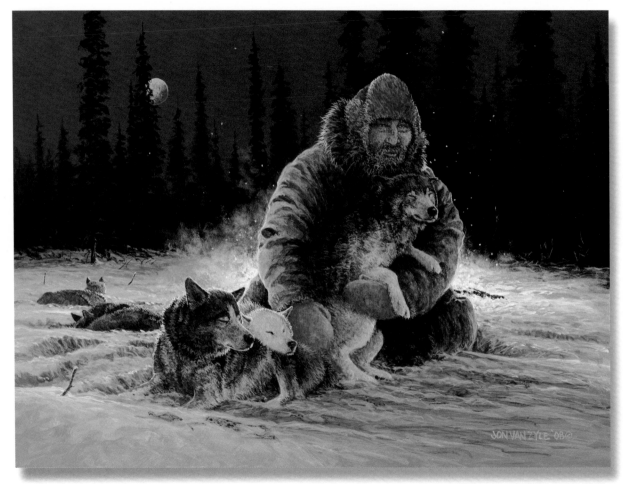

13" x 17" 400 printed $125

2008

Tired but True

Some of Jon's paintings try to capture the vastness and magnitude of Alaska, while this one went for a personal, intimate moment on the trail. Jon has pictured himself hunkered down by a roaring fire, bonding with his team. His leader Belle is in his arms.

Think about it, when you go walking with your pet dog on a leash, your dog is about six feet in front of you. You can pull the leash to control your pet and reach down to pat him for reassurance. From a musher's vantage point on the sled runners, his sixteen dog team can stretch over 40 feet in front of the sled. There are no reins to the dog and no steering wheel on the sled. All you have are voice commands and trust built over years of working together. So after hours of running, it's nice to gather by a fire, enjoy a meal together and share the adventures of your day.

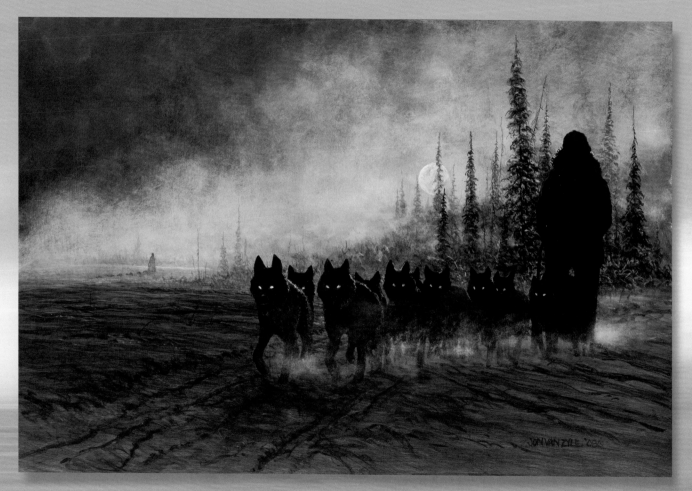

12½" x 20" 400 printed $125

2009

Ghost Riders

Many mushers prefer to let their dog team rest in the sunny warmth of the day, where they can comfortably relax. The dogs seem to enjoy the excitement of running at night when cooler temperatures keep them from overheating.

When temperatures drop to about 30° below zero and colder, habitation fog starts forming around you and your team. The moisture expelled from the musher and the dogs warm breath and body heat form a fog that follows you down the trail.

Jon tried to capture the surprising, otherworldly vision of a ghost team materializing out of the mist. In the light of a headlamp or film crew's cameras, the eyes of the frosted dogs glow red or green. As you may have noticed in a photo taken with a flash camera, blue eyes appear red. It's the same for the dogs: blue eyes glow red and brown eyes glow green, giving the team an ethereal look.

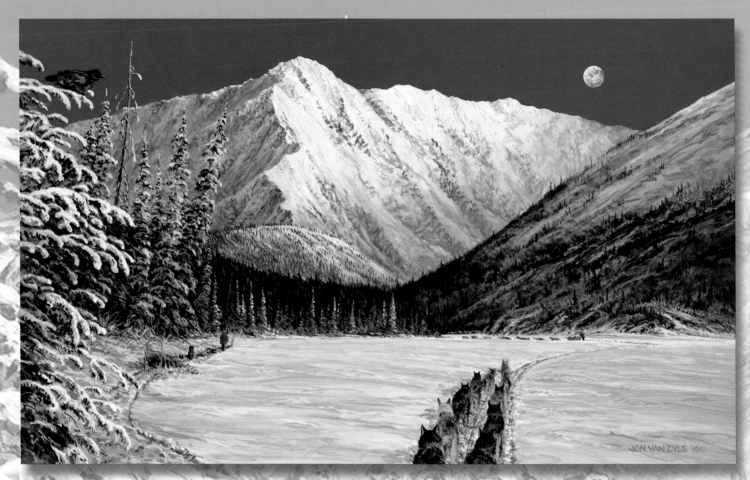

12" x 20" 400 printed $125

150

Trail Companions

For this print, Jon got to thinking about companionship on the race. Of course, you have your sixteen canine companions, and possibly a team or two that's moving at about the same speed. As the race stretches across the state, you could find yourself alone for periods of time between checkpoints.

There's an excitement in spotting game, and a comfort in seeing curious ravens, gray jays also called "camp robbers," and possibly a snowy owl. Even the man in the moon becomes a trail companion.

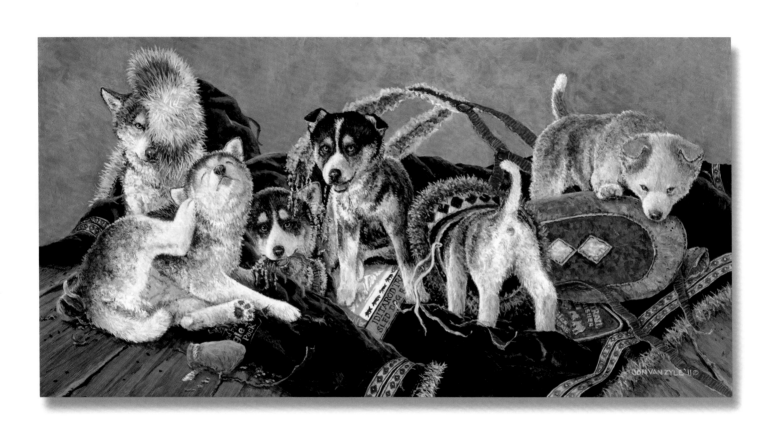

10" x 20" 400 printed $130

A Taste of the Trail

This is another humorous take on sled dog puppies' introduction to the Iditarod race. What dog owner hasn't lost a special something to a curious teething pup? I would imagine the smells of well-worn winter gear would be intoxicating and exotic to puppies. The furs, leather and well-worn harnesses each tell their own stories.

Jon also used this print as a vehicle to highlight the coveted icons of the race: the finisher's patch and belt buckle. He featured his beloved Wintergreen parka and a patch from Eagle Pack Natural Pet Food, our much-appreciated supporter. His well-used, well-loved mukluks were made by Athabascan seamstress, Martha Byrum, and were never touched by puppy teeth … ever!

Another project for 2011 was the publication of the coffee table book, *My Wrangell Mountains*, by the University of Alaska Press. This 225 page hardbound book features the stunning photographs of Swiss mountain climber/photographer, Ruedi Homberger. I created the text and Jon did the map and spot art.

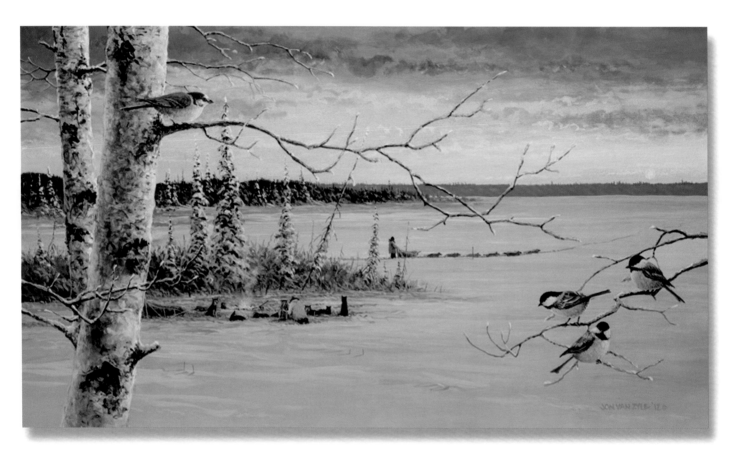

11" x 20" 400 printed $130

2012

The Spectators

Whether it's the gray jay and the chickadees watching the camper, the dogs watching the musher, or the musher keeping an eye on the other team, we all become spectators of the race.

Jon's original paintings are difficult to reproduce because of his painting style. He uses a method called "glazing," which builds many different colored layers of light washes of paint to achieve the depth and detail we see. Cameras have trouble recording the exact color. This print especially gained red during the printing process, so the sky is a more intense color than the original painting. Even with Jon making numerous press checks with the printer, it can still be a surprise at the end, and we may be the only people who notice the difference.

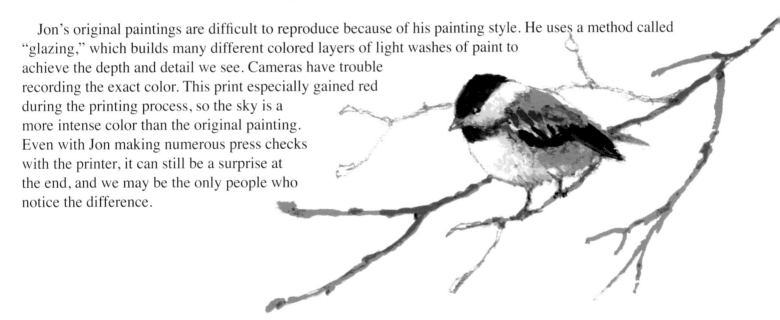

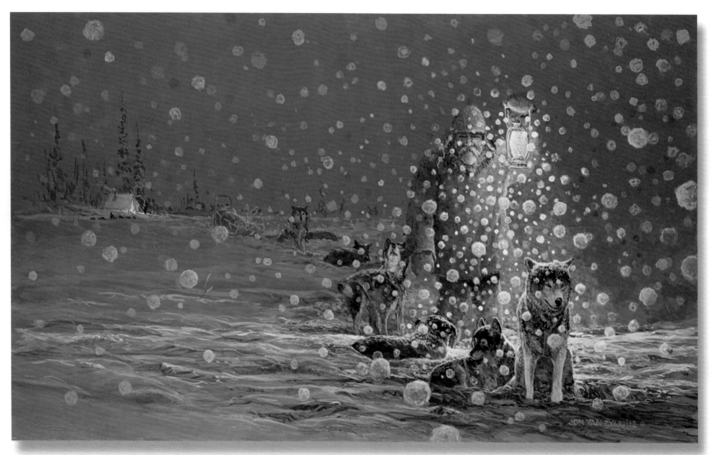

13" x 21½" 300 printed $130

2013

One More on the Way

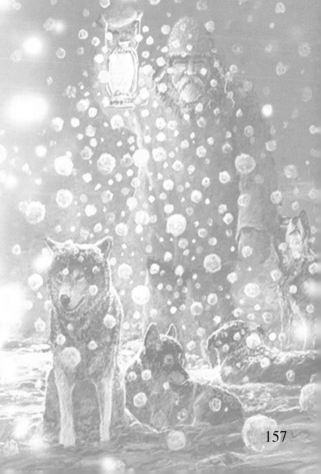

Jon recognizes the lonely vigil of a checker waiting in a blizzard for another team to arrive. Nowadays, with GPS trackers on each sled, there is less mystery about when a team is due to arrive. That being said, the weather still dictates what's happening and manages some unexpected surprises in the race each year. It's just those unexpected surprises that keep the race exciting and keep us all coming back every year.

This year, Jon switched to doing a Giclée print. Giclée (pronounced zhee-KLAY) is a newly-coined word for fine art digital prints made on inkjet printers. Special light-fast inks are used and the colors should remain true for up to twenty-five years if kept out of the direct sun. Also, there is no visible dot screen pattern.

Another advantage, once the art is digitally scanned, is that you can print one image, or many at a time. This really helps with storage considering Jon has produced nearly 400 print and poster editions over the past forty-five years.

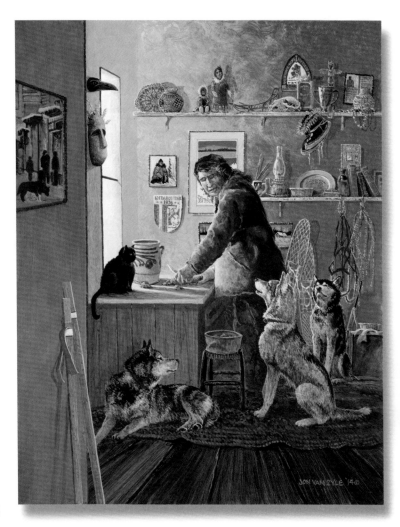

2014

A Nod to the Past

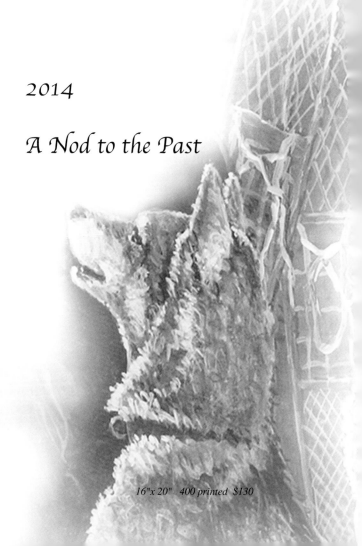

16"x 20" 400 printed $130

It's hard to face the truth that we are aging, but it's better than the alternative! Sled dogs, specifically Siberian Huskies, have been an integral part of Jon's life for over fifty years. As Jon's younger bride,(hahaha), Siberians have driven my life for the last forty years. Our kennel numbers have dwindled, our sweet dogs are twelve-to-sixteen years of age, and move about like we do.

"A Nod to the Past" acknowledges the important things from Jon's past, starting with his Dutch heritage. The lighting and composition are inspired by the work of the Dutch painter, Vermeer. As your eyes wander around the print, you'll spot many of Jon's race souvenirs and treasures. There are old blue glass, Dutch trade beads from the trading post in Kaltag and an old Iditarod race trail plaque. Historic photos and books share space with Native-made dolls and baskets that were either purchased, traded or gifted to him at village stops. You may even notice Jon's first Iditarod poster image framing the Native musher's face.

These souvenirs may be dust collectors on the shelf to some, but each treasure has a story and a memory that are priceless for us.

2015

One with the Night

In keeping with the graphic style Jon used on the 2015 poster, he continued it with this year's print. Using a montage of images, he tried to capture the feelings of being one with your dogs. The next step is for the musher and team to move as one with the night. A perfect, harmonious night run doesn't happen all that often, but when it does, you can bask in that memory for a long time.

On the way to that spiritual Nirvana, I also carry a montage of images from disastrous midnight runs. Fall training runs in Ohio meant meeting skunks, often enough that people could smell us coming before they could see us! Porcupines are a nocturnal Alaskan hazard, which necessitates carrying needle-nosed pliers in your first aid kit.

8½" x 18" 400 printed $120

Broken bones on icy trails, amorous rendezvous with dogs in season, confrontations with inebriated snowmachiners and angry moose are just a few of the nightmares that occur. Someone said, experience is what you get when you were hoping for something better.

Because of the lack of snow, the 2015 Iditarod re-start was moved to Fairbanks for a second time in race history. The race start in Anchorage was "slushed" in 40° F weather and pouring rain. Later on the race trail, teams encountered temperatures hitting fifty below zero, or colder, with the wind chill factored in.

This year also saw the passing of 81-year-old sprint mushing legend and Iditarod race veteran, George Attla. In his honor, the Iditarod Race Trail made a first time visit to his Athabascan village of Huslia.

Finally, in 2015, we premiered our long-awaited book, *Iditarod: The First Ten Years*. The response was amazing, and better still were the massive book signings attended by most of the 100 contributing authors. It was truly a family reunion.

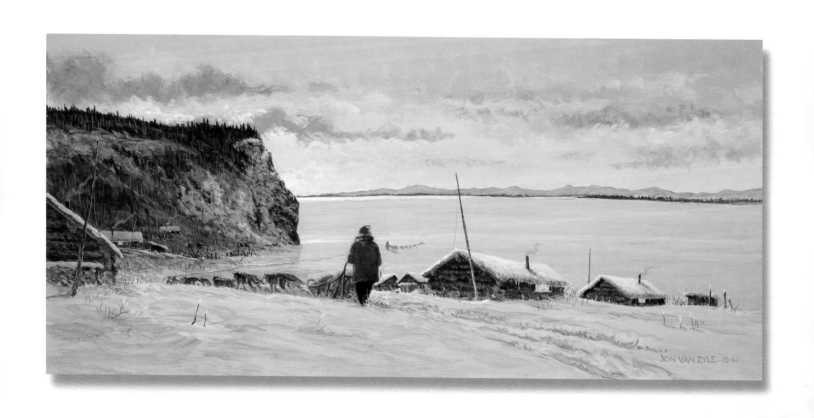

20"x 9" 400 printed $130

2016

Ruby Sky

Jon chose to revisit the village of Ruby for this year's print. He has pictured a cold, clear sunset and good trail conditions for the 52 mile run down the Yukon River to Galena. Having a team visible ahead of you gives your dogs a little added incentive to run … it doesn't get any better than that.

Jon and I both have a warm spot in our hearts for the Athabascan village of Ruby. Whether we travel by dog team or airplane, winter or summer, the warmth of their hospitality leaves a rosy glow.

Iditarod mushers Don Honea and Emmitt Peters still live in the small community of less than 200 people. Emmitt, aka the Yukon Fox, won the Iditarod in 1975, the last rookie to win the race.

163

Afterword

So what will the future bring? I imagine Jon will continue to paint and create until he can no longer hold a paintbrush. At that point, knowing Jon, he'll duct tape a brush in his hand and keep painting.

Jon is so thankful for the popularity of his artwork and, in some small way, his ability to continue to support the race he loves so much.

Most importantly, he appreciates his supportive, inspirational fans who still visit our shows, our website, and our home. That contact continues to fuel the creative fire.

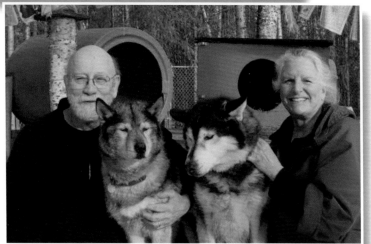

The same suspects, photographed 16 years later.

About Jon and Jona

Jon Van Zyle is well-known among mushing fans worldwide, especially in North America and Europe. He is known for his richly detailed and distinctive paintings of Alaska's wildlife and landscapes.

More than 350 of his originals have been published as limited-edition prints over more than forty years. He has illustrated dozens of books including *Jon Van Zyle's Alaska Sketchbook* and the best-selling *Iditarod Classics*, and he continues to illustrate at least two children's books each year. In addition, his art is used on many products for various companies. Art is his life, and all of Alaska has been his inspiration.

Jona Van Zyle's longtime love of wildlife and sled dogs has influenced all the facets of her life and art. She has written *Iditarod Memories* and *My Wrangell Mountains* and contributed stories to *Iditarod: the First Ten Years*. Jona is also an artist working mainly with leather and beads. She has exhibited her work in numerous shows across the U.S. and Europe. Her art appears in collections ranging from Denali National Park and Preserve to the White House.

Jon and Jona live happily with their huskies in the art filled home they built near Eagle River, Alaska.

VISIT JON AND JONA'S ONLINE GALLERY

Original paintings and sketches, limited-edition prints, posters, jewelry, bead work and books can be purchased from the artists' online gallery, www.jonvanzyle.com.

For information about original commissions, contact jonvanzyle@gmail.com

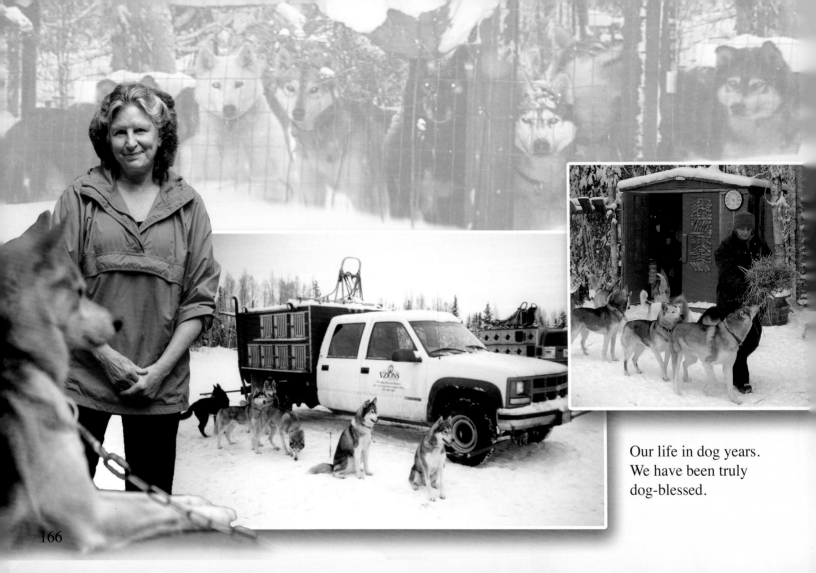

Our life in dog years.
We have been truly
dog-blessed.

166

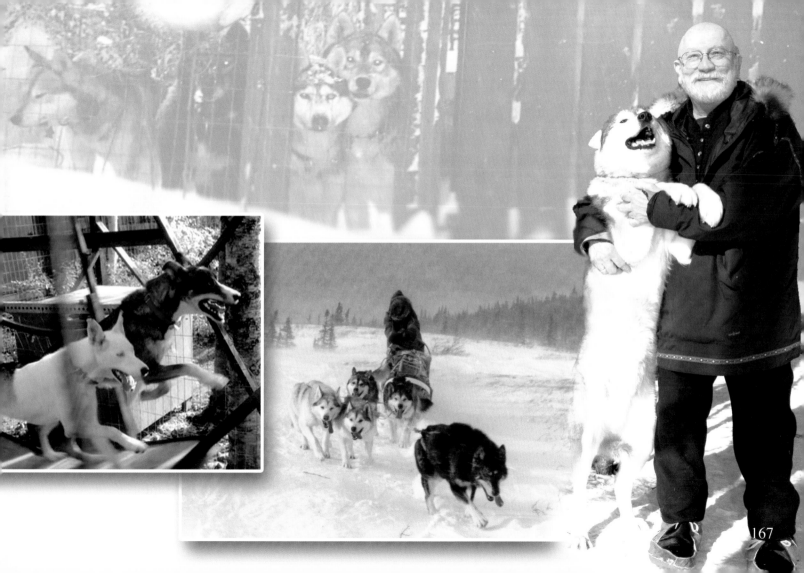

THE SECONDARY ART MARKET

When an entire edition of artwork is sold out, traditionally the price of the art is doubled. The price and value are determined by the popularity and the availability of the art. Jon has nothing to do with setting the price.

Sometimes you can find Jon's older art online (on ebay, for instance), occasionally at second-hand shops or garage sales, and most reputably at an established gallery that is familiar with Jon's art.

Galleries we currently recommend are:

The Art Shop Gallery – Homer, AK
Karin Marks
artshopg@xyz.net

Scanlon Art Gallery - Ketchikan, AK
Susan Peters
sales@scanlongallery.com

Town Square Gallery – Wasilla, AK
Janet St. George
tsart@mtaonline.net

Arctic Rose Gallery – Anchorage, AK
Jana Latham
arcticrose.artcenter@gmail.com

Internationally, we currently recommend:
Wildlife Shop – Stäfa, Switzerland
Heidi Müller-Ruoff
www.wildlifeshop.ch

Additional Links

Information for the "Teacher on the Trail" program:
www.iditarod.com/teachers

For Information on auroras:
Geophysical Institute of the University of Alaska Fairbanks
www.gi.alaska.edu

For everything you wanted to know on the early race years:
Iditarod the First Ten Years
www.iditarodfirsttenyears.com

For more about the Van Zyle's:
visit our online gallery
www.jonvanzyle.com

This license plate is issued by the state of Alaska only to official Iditarod finishers.
As of March 2016, 765 mushers have finished the Last Great Race Race. Jon holds the honor of being the 77th musher to complete this race.